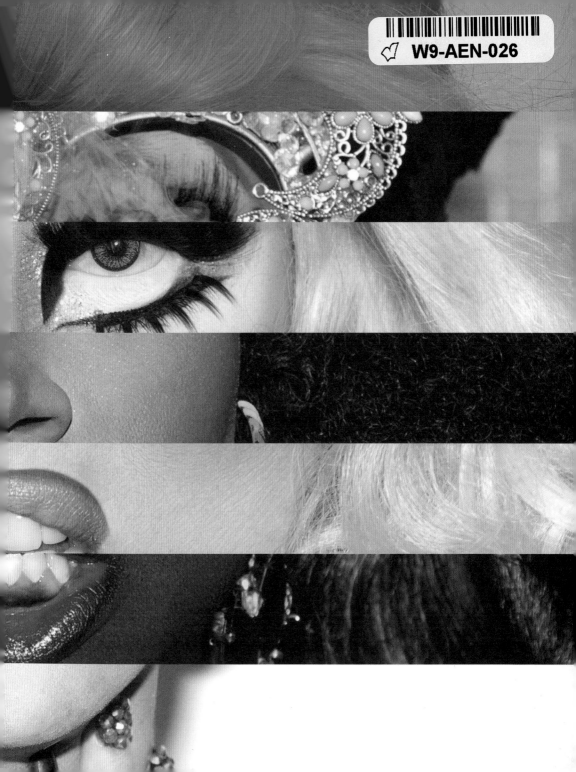

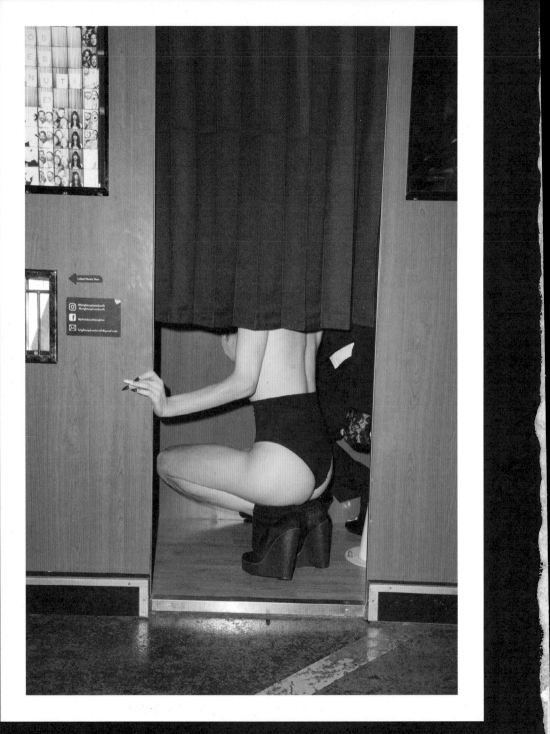

ALRIGHT DARLING?

THE CONTEMPORARY
DRAG SCENE

GREG BAILEY

LAURENCE KING PUBLISHING

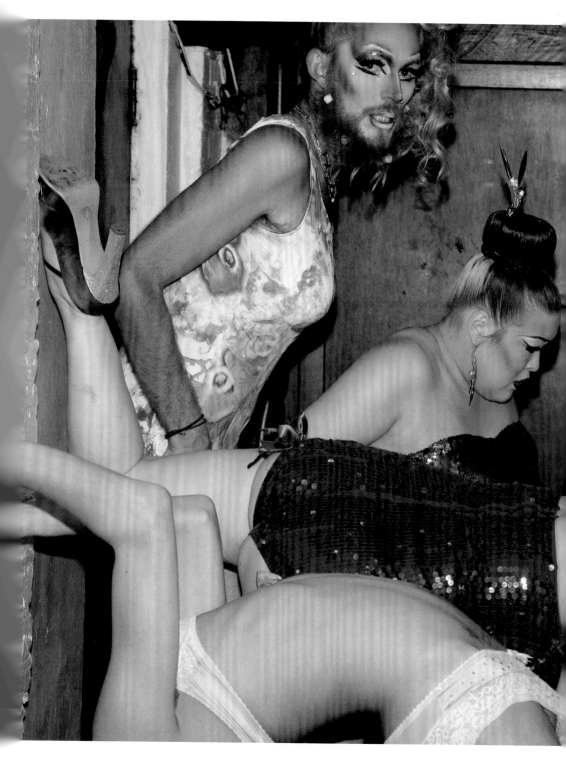

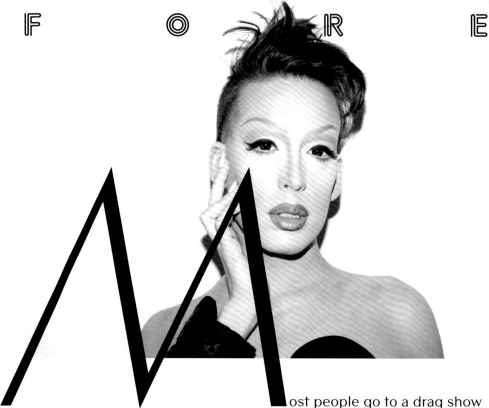

Most people go to a drag show because they want to have a good time. Maybe they want to get twisted; maybe they want to get laid. Maybe a little bit of both. But what draws us there is beyond the logical mind. It's a feeling, an instinct, something that happens between the root and the sacral chakras embedded in our ass and our pussies.

It's not a coincidence that the popularity of drag has exploded in recent years and continues to grow. Whether it's on TV, Instagram, the covers of major magazines, in music, film or fashion, we can't seem to get enough. We don't know why we like it — we just do.

Most people don't realize that when we witness the art of drag we are taking part in a divine, sacred act. And we are performing our duty as citizens of a dying Earth to tip the energetic scales rightfully in the direction of the feminine.

Drag is the ecstatic celebration of divine feminine energy. Drag queens are priestesses. They perform precise preparation rituals passed down painstakingly by the generations that came before them. They alter their appearances, and don ostentatious garb and costumery, in order to perform exuberant dance and movements before people who have congregated to witness the ceremony. Whether we know it or not, drag queens are the truth-tellers and soothsayers of our society. And we love them.

For the drag queen, drag doesn't make much sense. It takes all our time and our money and our energy. It ruins our feet and our spines and our skin and our sheets. It makes our roommates move out and our grandmothers shake their heads. Drag fucking hurts. But we do it anyway.

Drag is more than the sum of its parts. Alone, the makeup and the hair and the clothes don't amount to very much. But at some point in the process for the drag queen a transformation occurs. Something springs into existence that wasn't there before. And that's why we do it anyway.

Greg Bailey's photos capture that something, that inexplicable, fleeting essence of drag. It's not unattainable airbrushed perfection — what Greg captures is raw and real. But in his photos, he also sees us the way we see ourselves — stunning and vulnerable, larger than life, brash and beautiful, ridiculous and perfect.

In this book you'll find the images and stories of those who are part of a sacred and divine sisterhood, people who have come to drag and people whom drag has come on to. Maybe you're a drag connoisseur. Maybe you're a casual drag enthusiast. Or maybe you just like to look at pretty things. But I believe it doesn't matter how the gospel touches you, as long as it touches you. So enjoy being touched.

ALASKA THUNDERFUCK

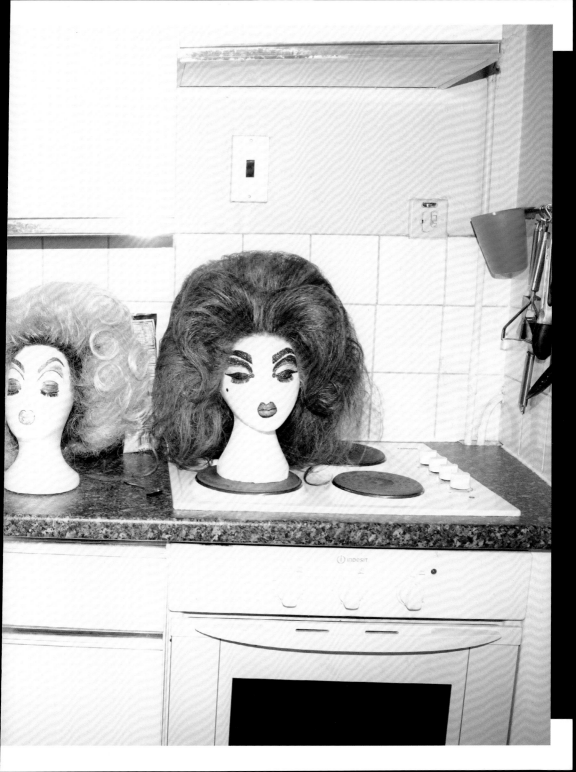

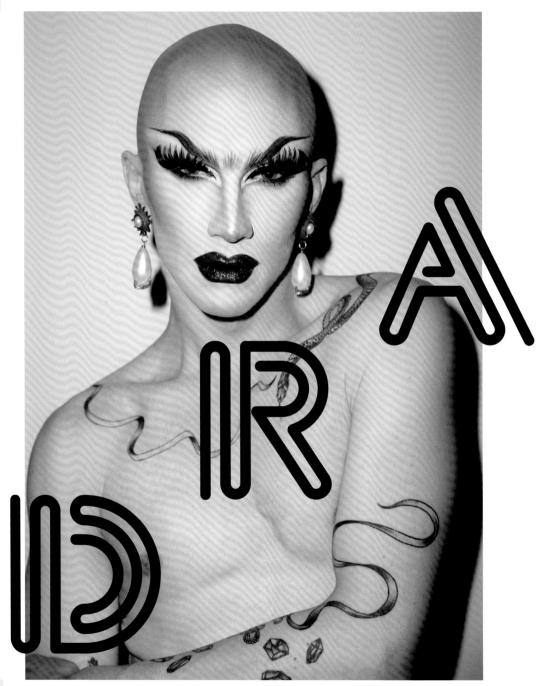

Sasha Velour, winner of *RuPaul's Drag Race* series 9, photographed in Brighton in January 2018

DRAG isn't just fabulous; it's a political statement, and it makes you question your understanding of sexuality and gender. Once you think you have a grasp on what drag is, or start to see a pattern, it surprises you by reacting against that pattern. The world of drag is constantly evolving. It questions, it revolts, it does not conform, but it always welcomes you with a wink and a smile that says 'Alright Darling?'

When I first started working as a photographer with drag performers, the imagery I was creating was being lost online. It would occasionally resurface on a Tumblr page or pop up on a blog, but the contemporary drag scene wasn't as embedded in modern pop culture as it is today; there just wasn't the pull towards it. The now cult TV show *RuPaul's Drag Race* was airing in the United Kingdom in the early hours of the morning to a relatively small audience, but, needless to say, I was hooked from season one in 2009. After the third season had aired, feeling a bit more confident in myself and my work, I decided to congratulate the new winner of the show, Raja Gemini, never expecting a response but still really hoping for one. Six years later, she's been the cover star of my self-published zine *Alright Darling*,

we've got drunk together and partied in Hollywood, and we've visited each other's homes. Working with and getting to know someone like Raja helped me as a photographer more than she knows, and her relaxing demeanour silenced any anxiety I might have had about photographing celebrated personalities in the scene.

I had hardly even begun to think about creating something tangible from what I was doing when I started talking to Raja. It was actually another drag-race alumna that helped to start the ball rolling, Willam Belli. She was performing for the first time in the United Kingdom after her infamous disqualification from the show. I travelled up to London to photograph her in her room at the Imperial Hotel (there was nothing imperial about it, but the abundance of plain white walls that you'd expect in a mid-range hotel was the perfect backdrop for a photoshoot). Following that shoot, Willam and I worked on several editorial projects together for some mainstream magazines.

After being rejected for what felt like the hundredth time, however, and realizing that I wouldn't be able to fulfil my promise to Willam that I would get her a cover story, I decided to create something of my own, something that documented drag in a way that wasn't campy or throwaway, but collectible and special. The zine *Alright Darling* was born in 2015 with not just Willam as the first cover star but also the other two members of the drag supergroup the AAA Girls, Alaska Thunderfuck and Courtney Act. We took over an American Apparel store in Brighton for a night and

used the windows as a ready-made set for the shoot. In between outfit changes, Willam strutted from window to changing room in just a blonde wig and her tuck, giving the curious onlookers outside something to be properly shocked at.

Since its launch, *Alright Darling* has allowed me to hang out with Manila Luzon in downtown Los Angeles, get wasted on vodka with Adore Delano, spend a morning shopping in Primark, Cardiff, with Jinkx Monsoon and Michelle Visage, and have Katya decipher which Hogwarts house I would be in (the shady c**t said Hufflepuff!). But, above all, it's allowed me to create friendships with a group of people that until a few years ago would have been laughed at and shunned by the mainstream for what they love doing. Drag has been propelled from being a subsector of the gay community into the spotlight of today's culture. I'm proud to be part of and to document a scene that's beautiful and powerful. Its strength doesn't come from dominance, oppression or conformity, but from love, happiness and inclusivity.

This book offers a glimpse into the contemporary drag scene with a mixture of styled portraits and candid backstage moments from some of the most recognizable faces of drag today. It includes performers who have shaped the way I see the world and who work hard for their art, and I hope it communicates the positivity in what they do.

GREG BAILEY

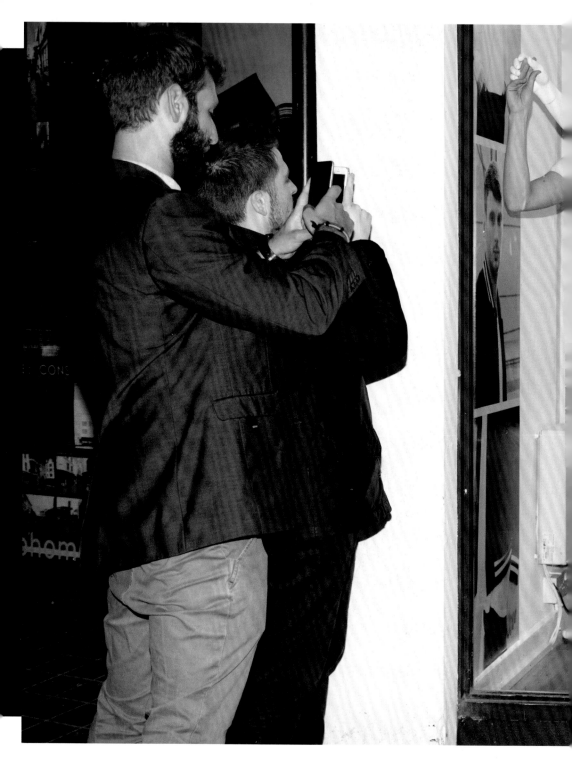

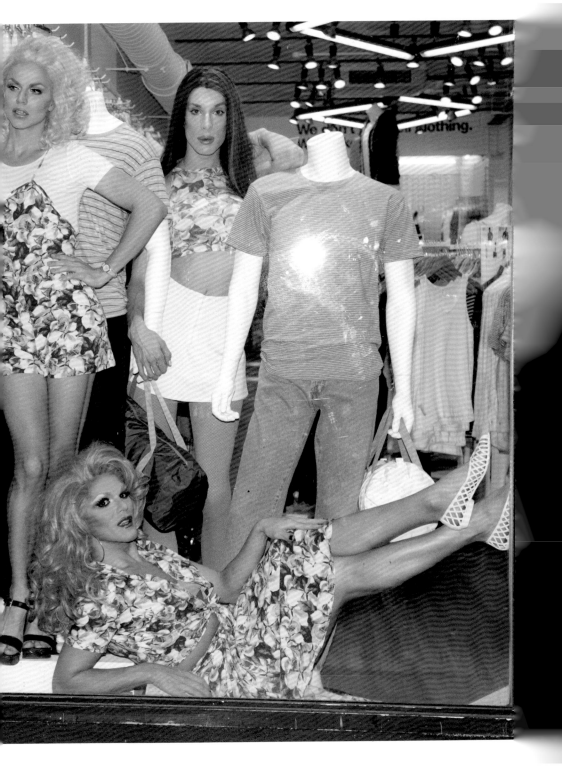

"FUCK THE WORLD — PLAY IN GLITTER!"

Adore Delano

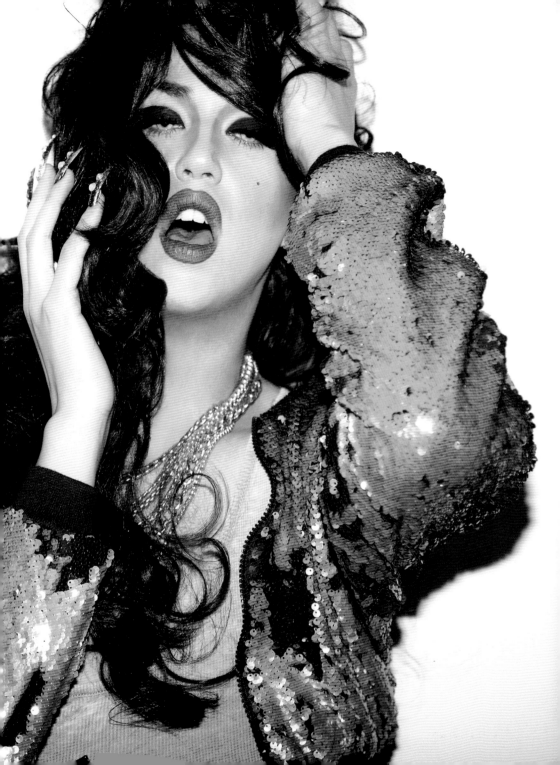

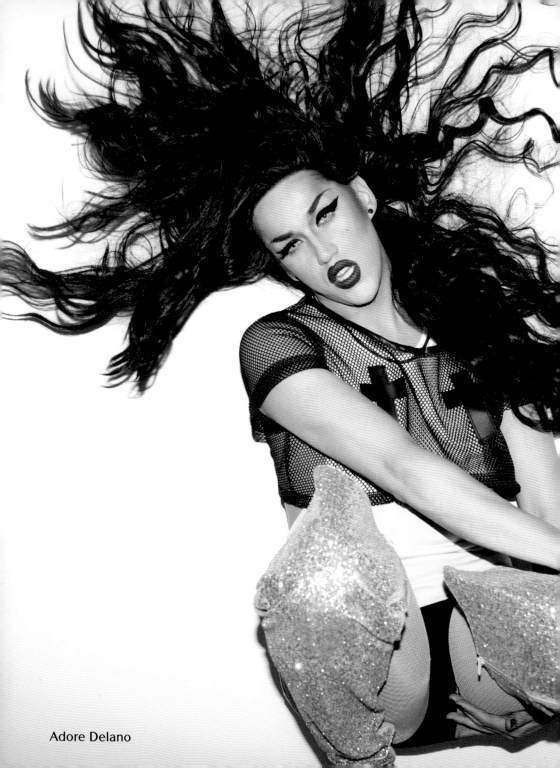

Adore Delano

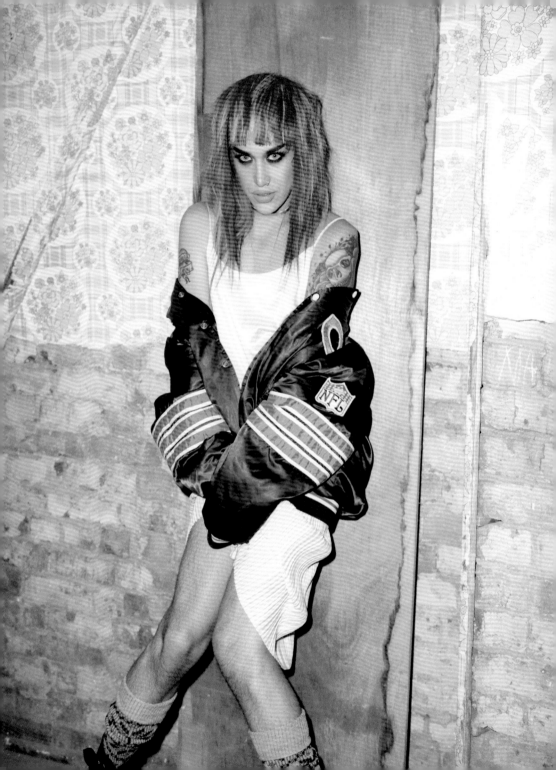

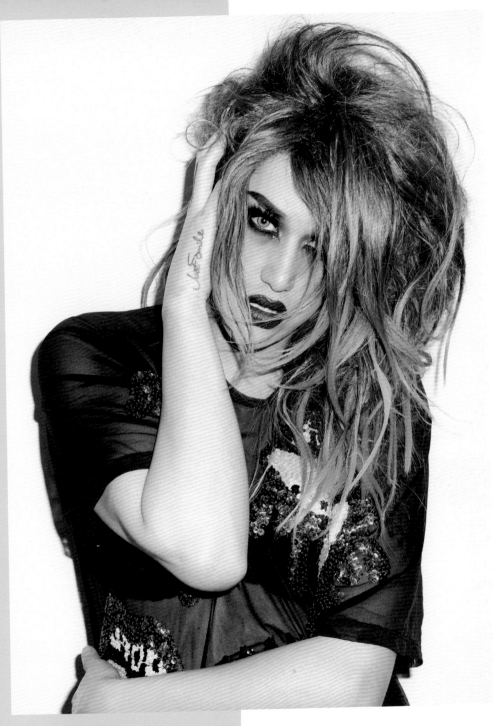

Adore Delano

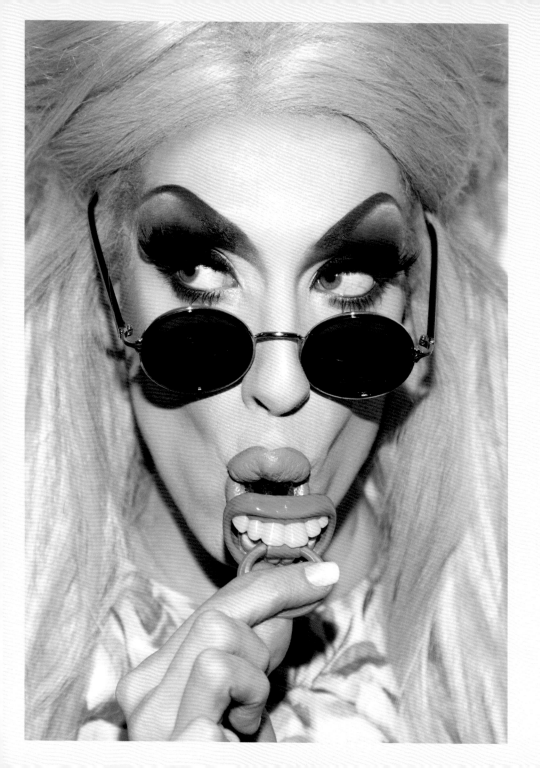

"DRAG

is primarily adhesives.
The drag queen glues things
TO HER EYES,
TO HER LIPS,
TO HER EARS,
TO HER FINGERS,
TO HER HEAD,
HER HAIR,
HER CHEST,
HER GENITALS,
 and anywhere else
 glue can be applied.

Alaska Thunderfuck

The kinaesthetic awareness
involved in moving
and (barely) functioning
while managing all these
unconventional adhesions
results in extreme beauty
and even more extreme
pain and annoyance.

AND YET ...

we are compelled to do it anyway.

So either the drag queen
is inherently a masochist,
or drag is a special,
inexplicable magic.
I think it's a little of both."

Alaska Thunderfuck

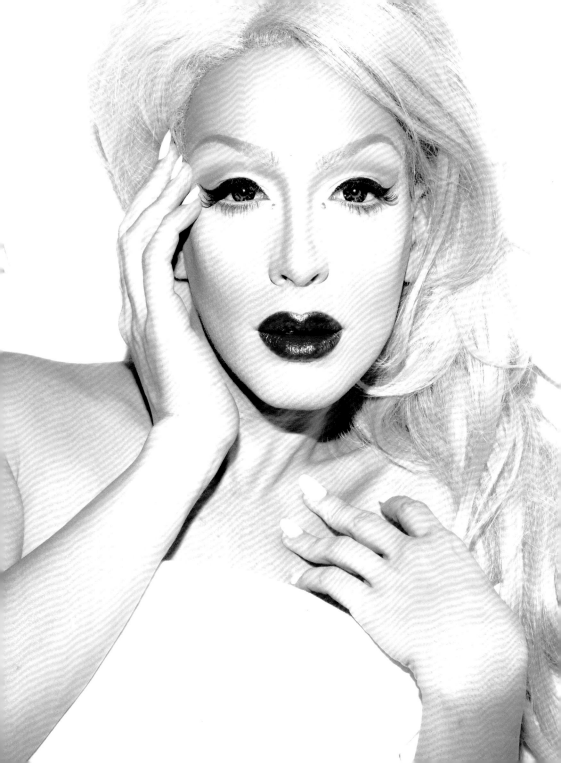

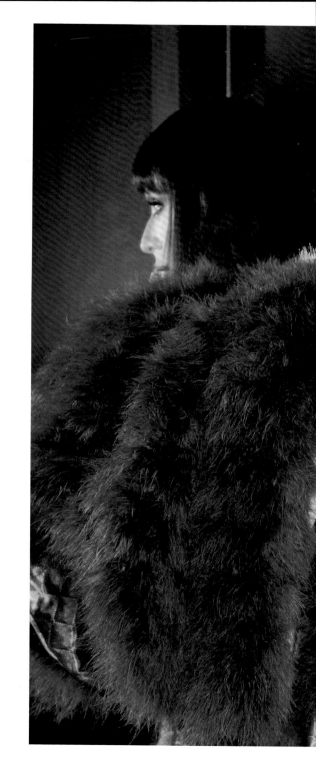

Alaska Thunderfuck

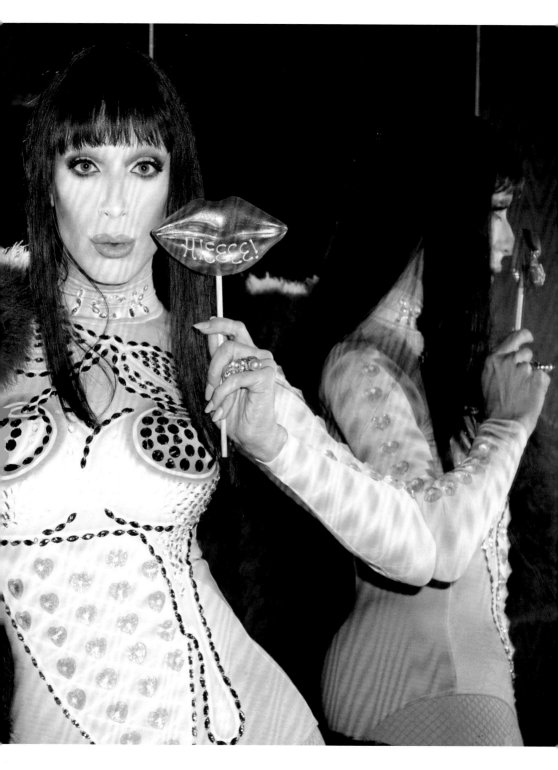

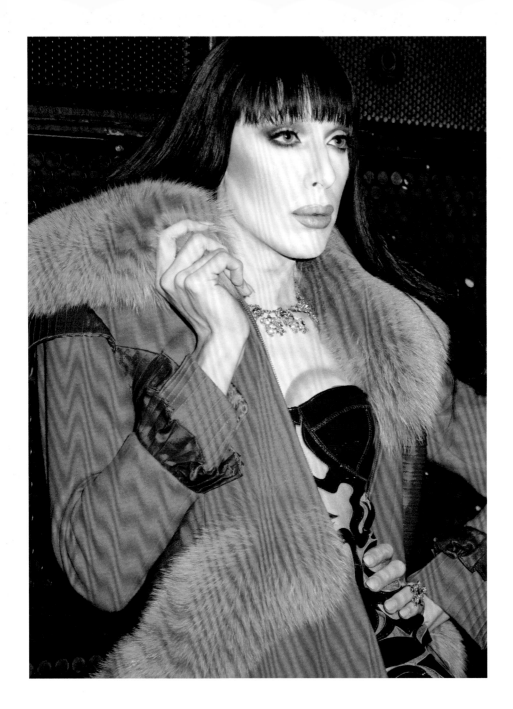

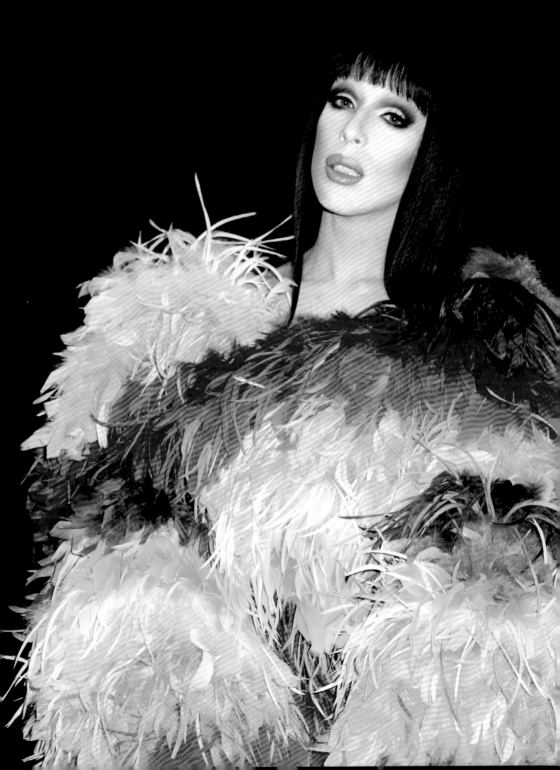

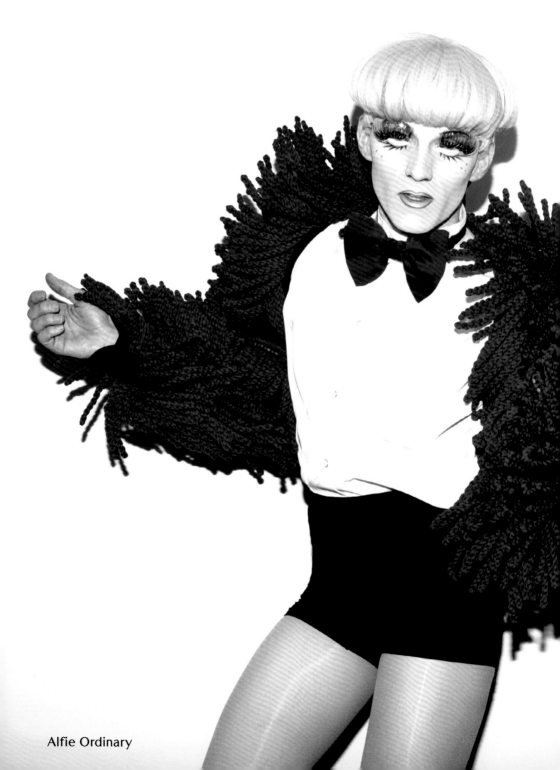

Alfie Ordinary

"AS A DRAG PRINCE
I DON'T BELIEVE
YOU HAVE TO CROSS
A GENDER BOUNDARY
TO BE
FABULOUS."

Alfie Ordinary

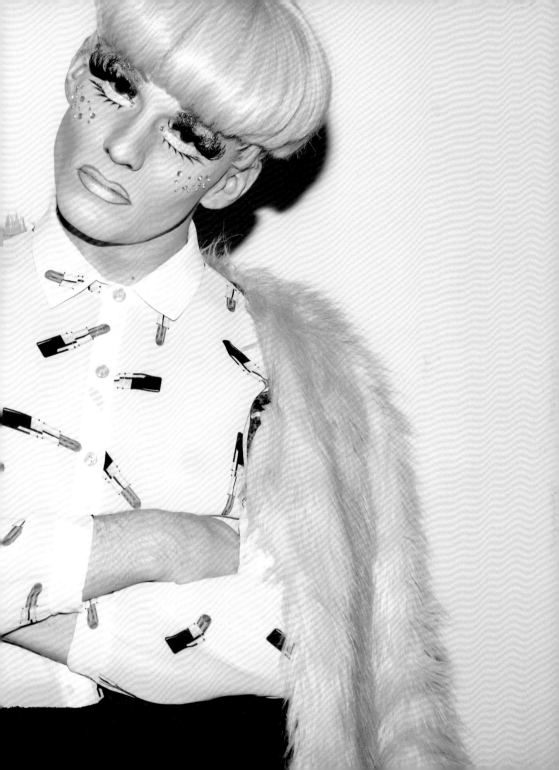

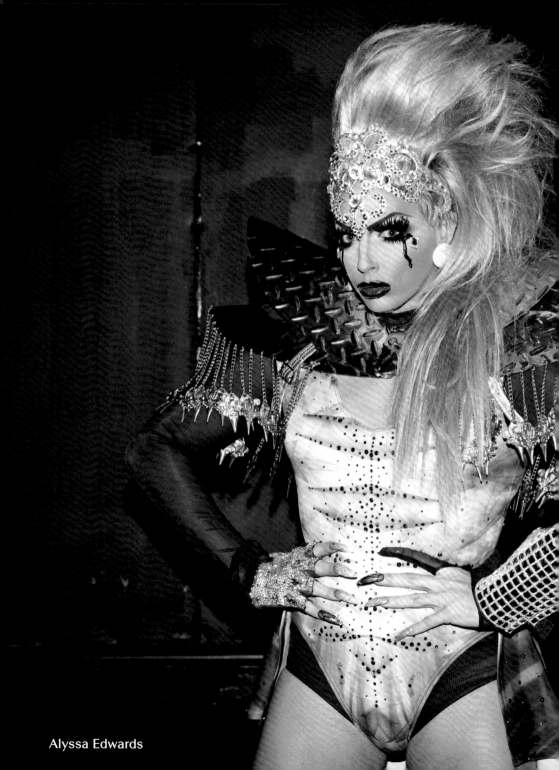

Alyssa Edwards

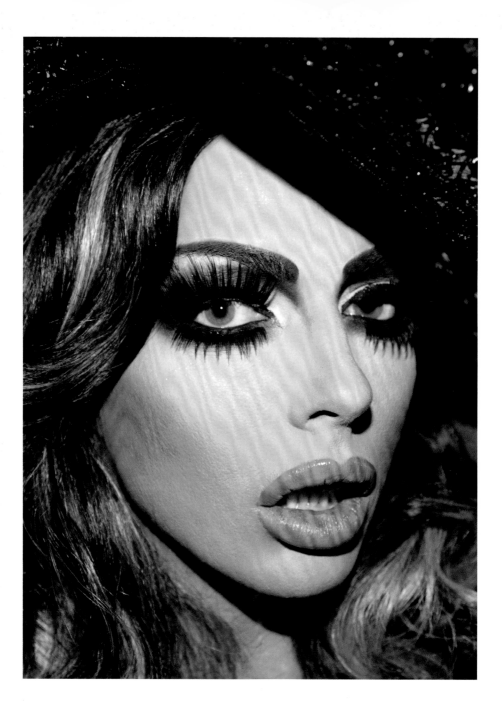

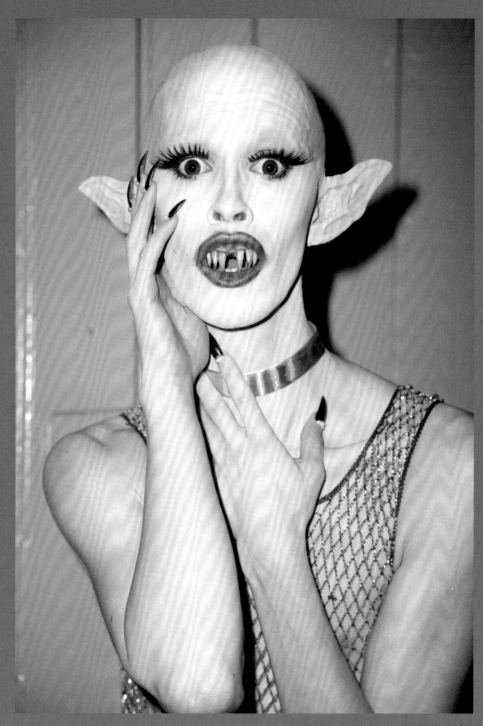

Arran Shurvinton

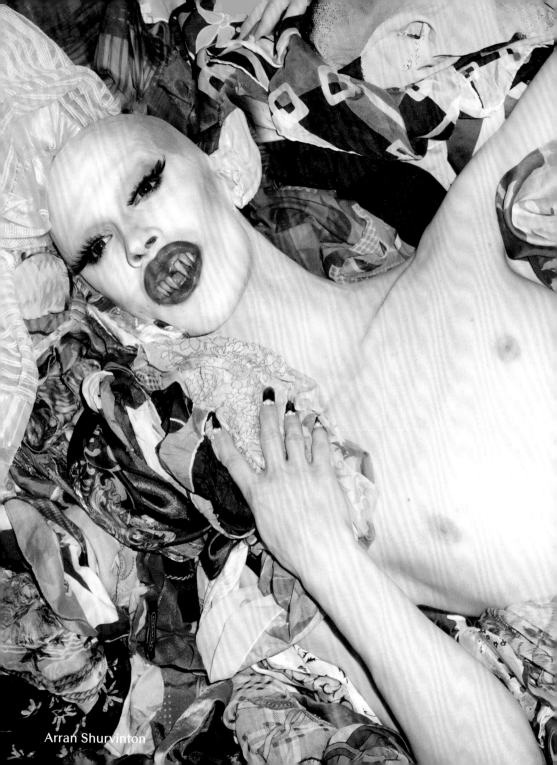

Arran Shurvinton

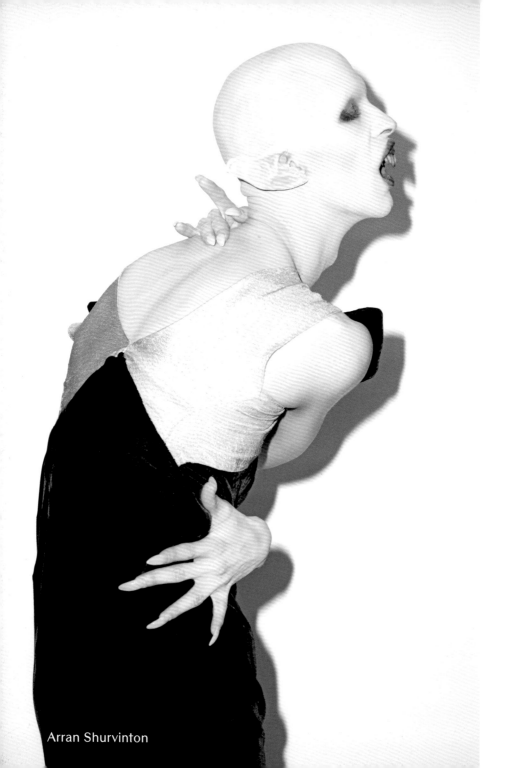

Arran Shurvinton

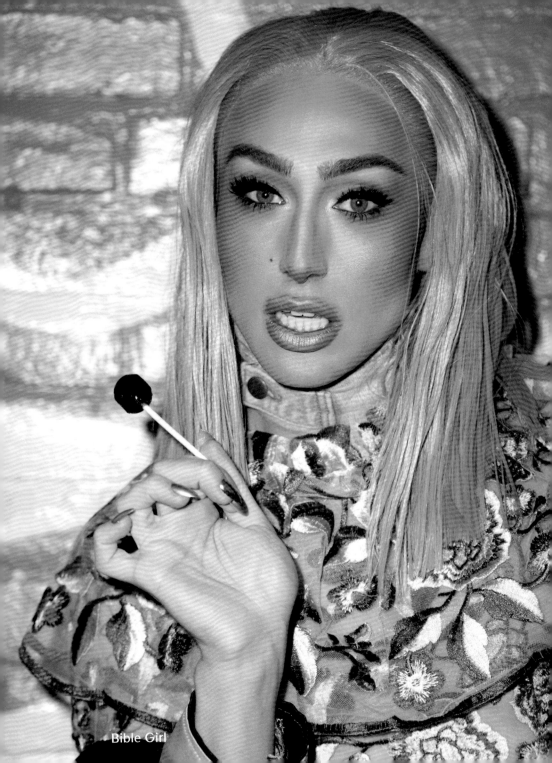

Bible Girl

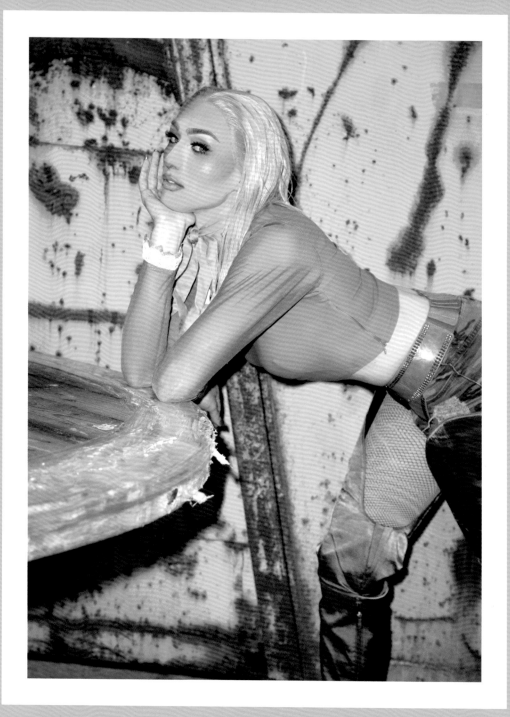

Bible Girl

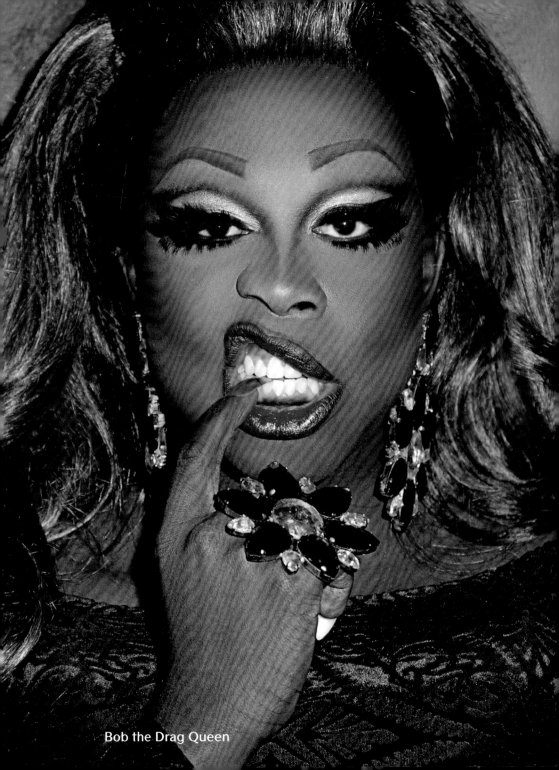

Bob the Drag Queen

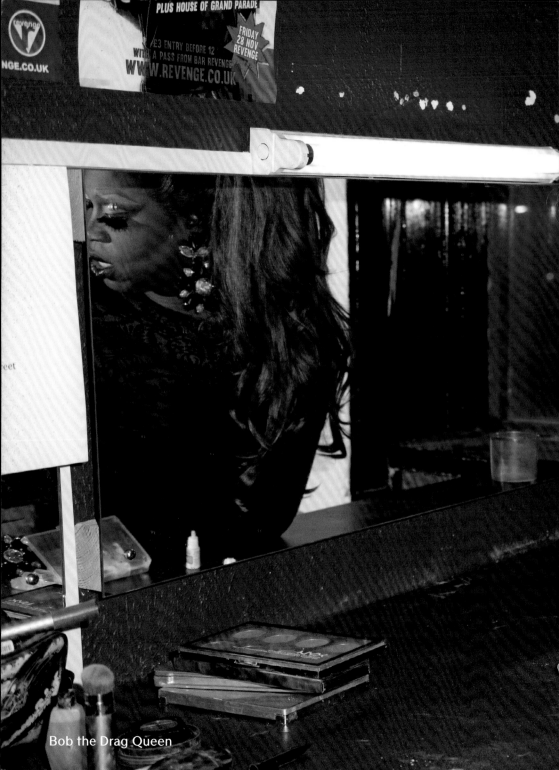

Bob the Drag Queen

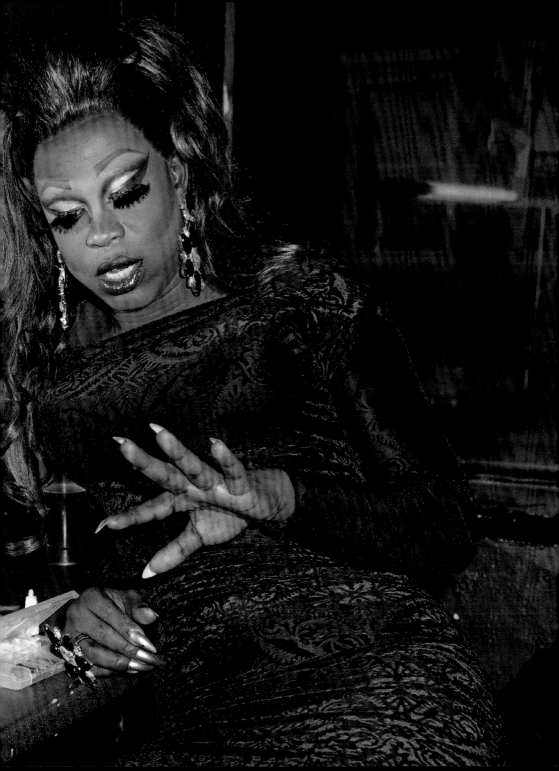

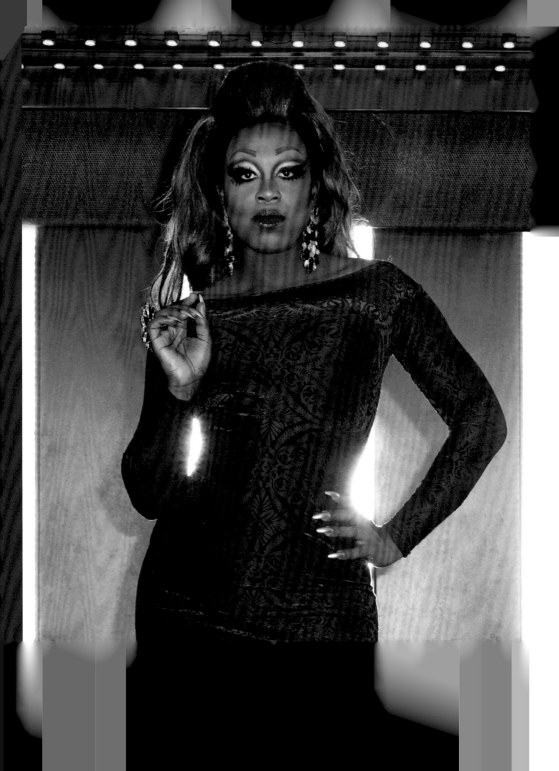

"In **NYC**ew **Y**ork **C**ity
if you can't dance
we're not going to point out
the fact that you can't dance;
we're going to celebrate
what you do well!
And that is why I can thrive
in New York City.

I can thrive there
because they focus
on my comedy.
Sherry Vine's not doing
death drops and drop splits,
but people love her
for what she does well."

Bob the Drag Queen

Bourgeoisie

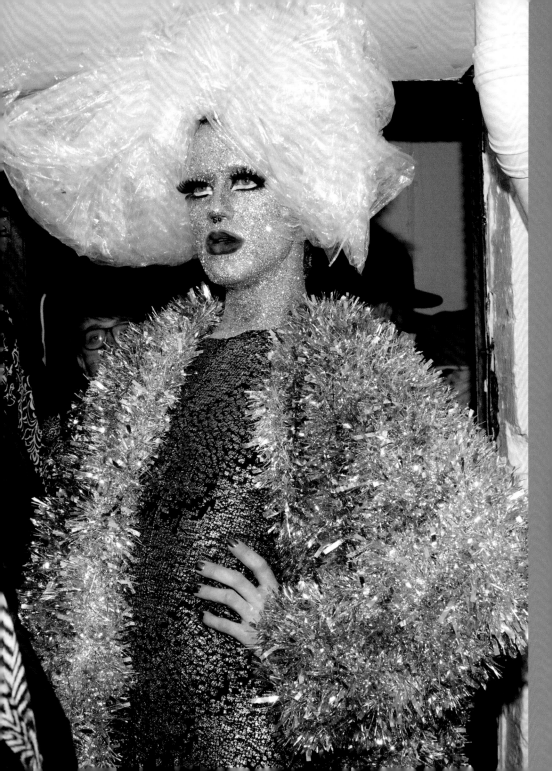

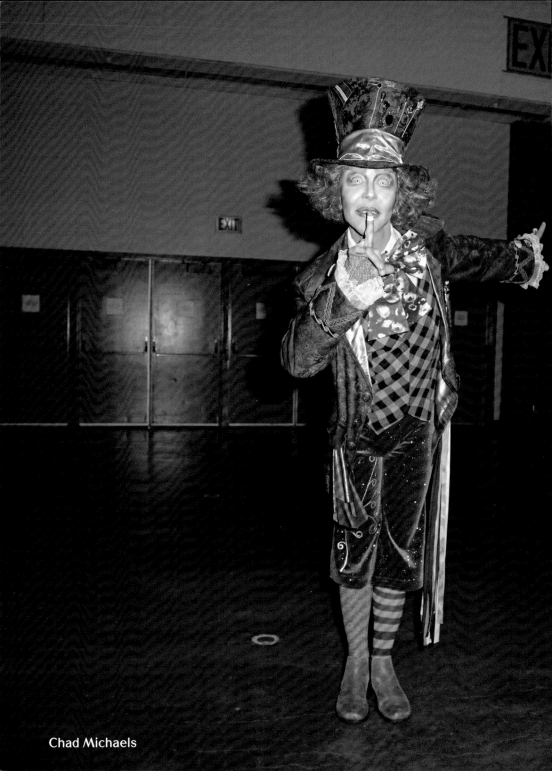

Chad Michaels

"I've always tried to live by the words of my great-aunt Louise, who said,

'IF THEY CAN'T TAKE A JOKE,

FUCK 'EM WHERE THEY BREATHE!'"

Charlie Hides

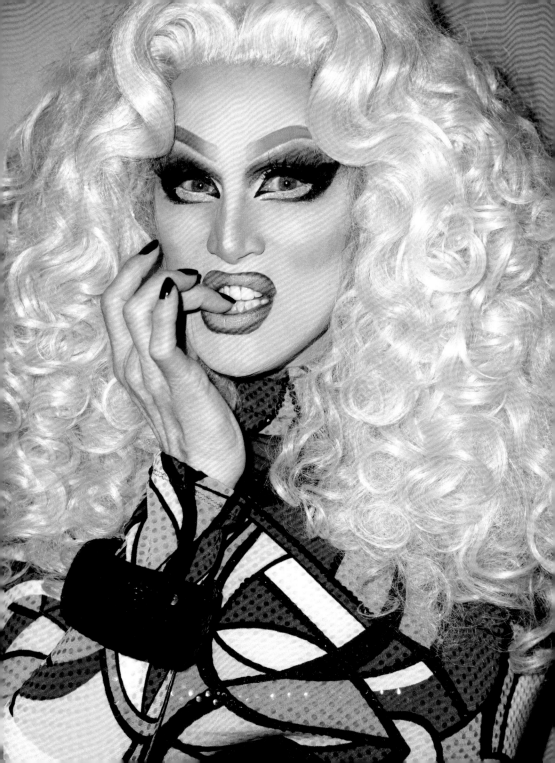

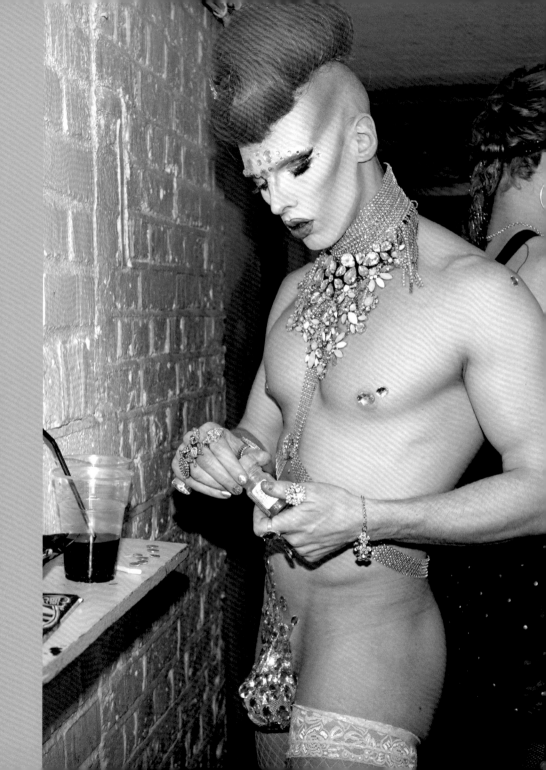

Cheddar Gorgeous

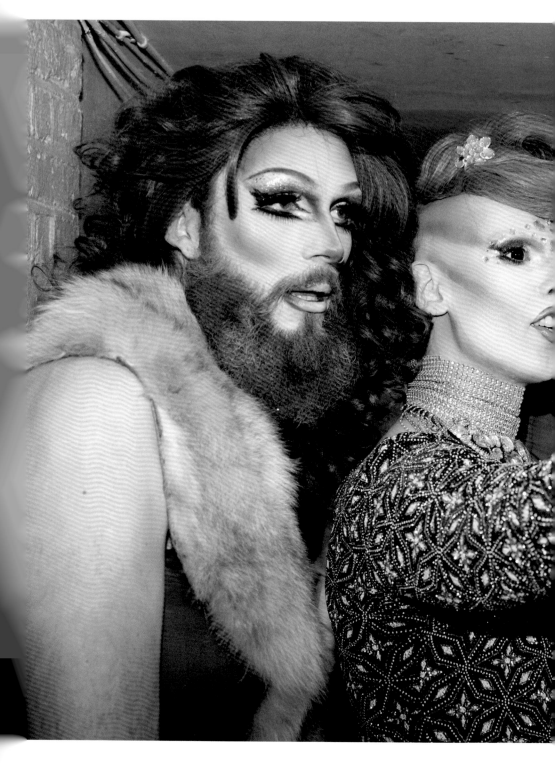

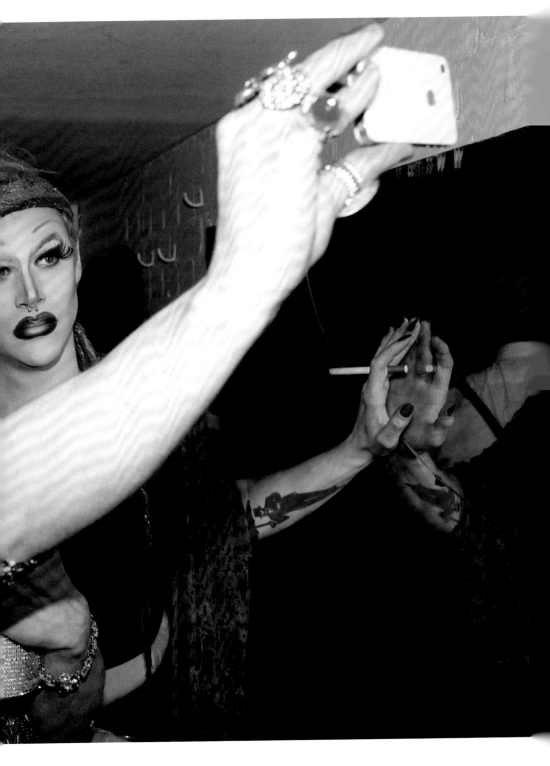

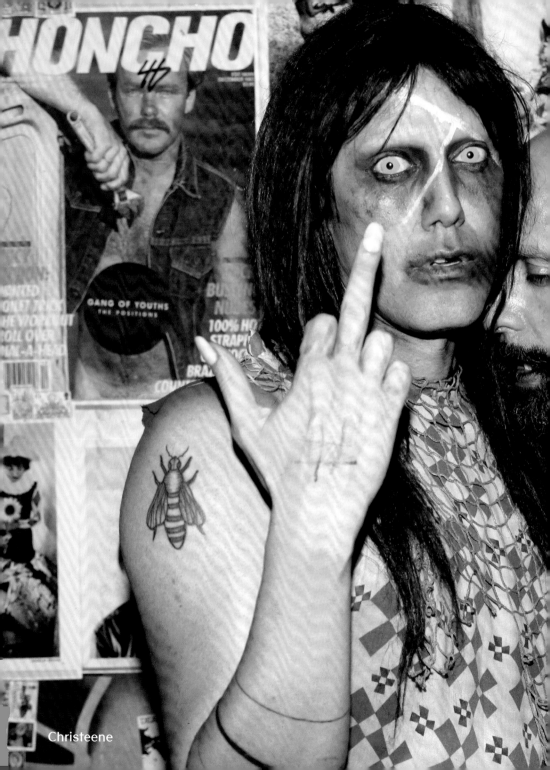

Christeene

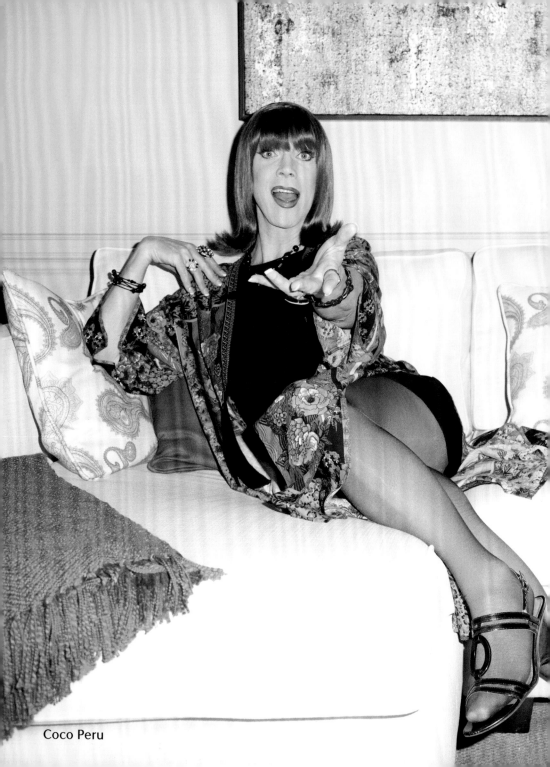

Coco Peru

"WHENEVER I SMELL
'STREET
MEAT'
(vendors cooking hot dogs on
the street and that sort of thing),
I THINK OF MICHELLE VISAGE,
AND I THINK SHE
WOULD BE PLEASED BY THAT."

Coco Peru

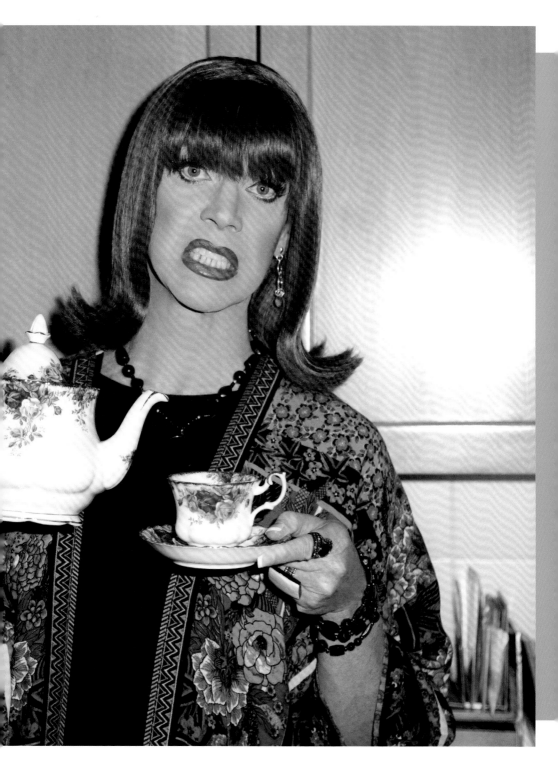

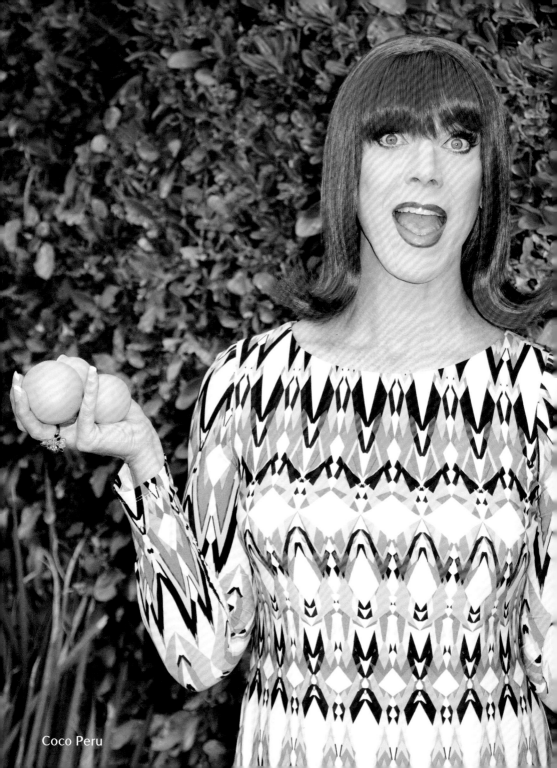

Coco Peru

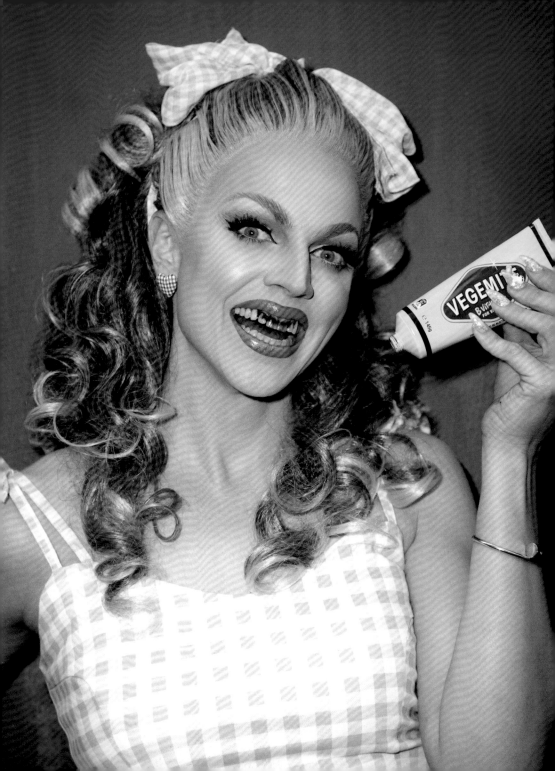

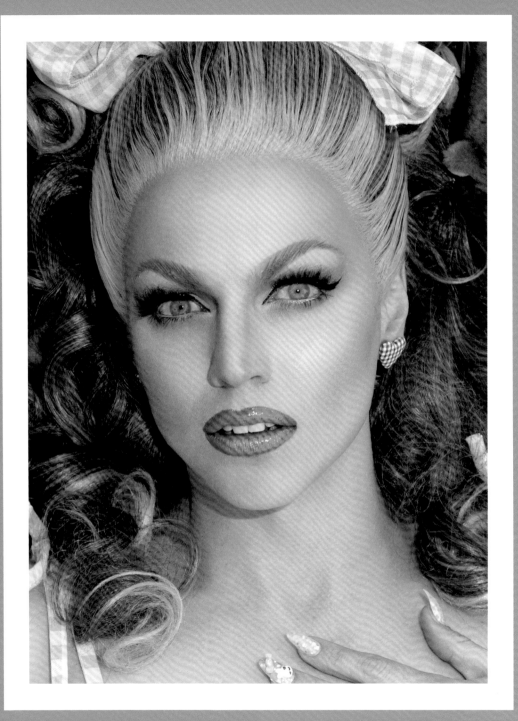

Courtney Act

Courtney Act

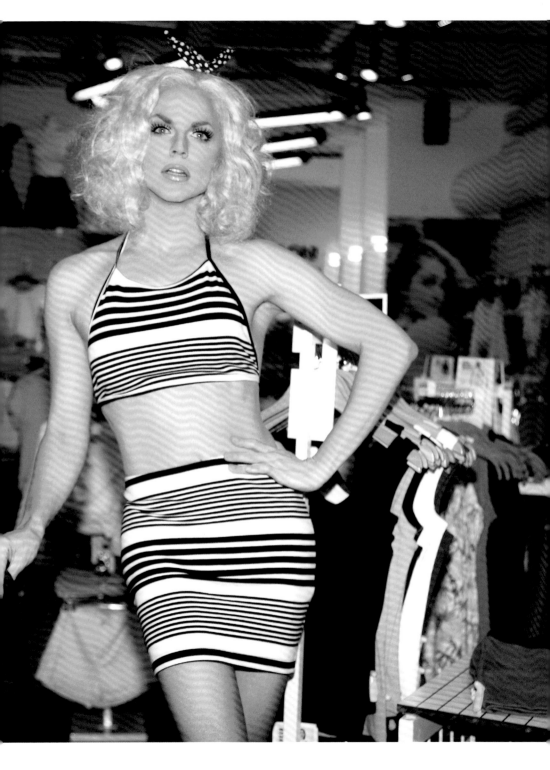

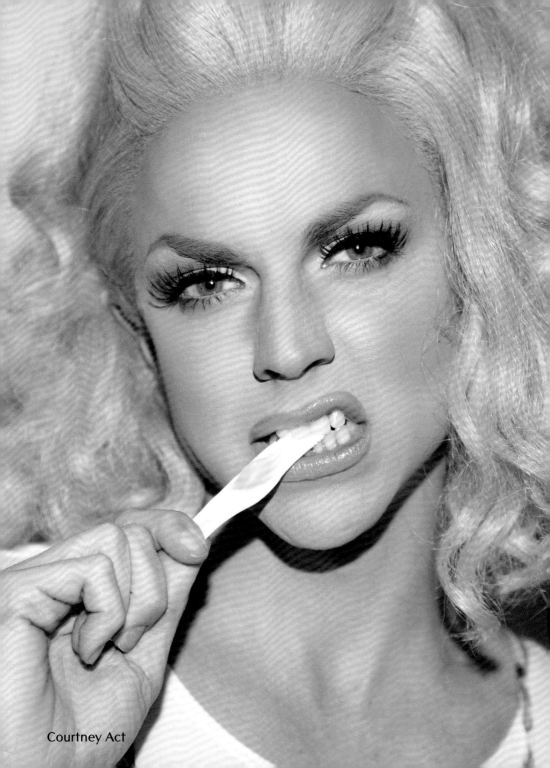

Courtney Act

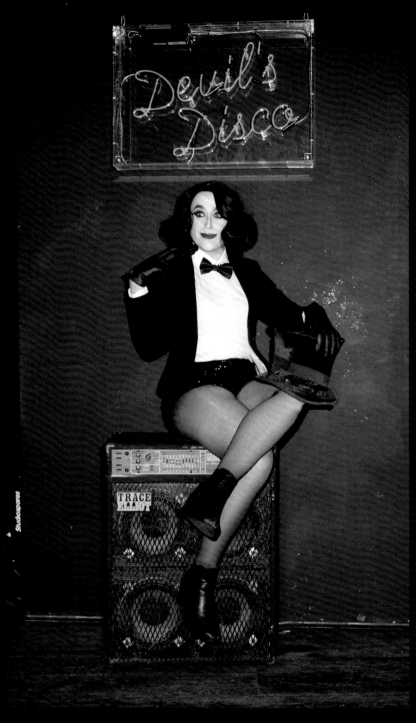

Crystal Lubrikunt

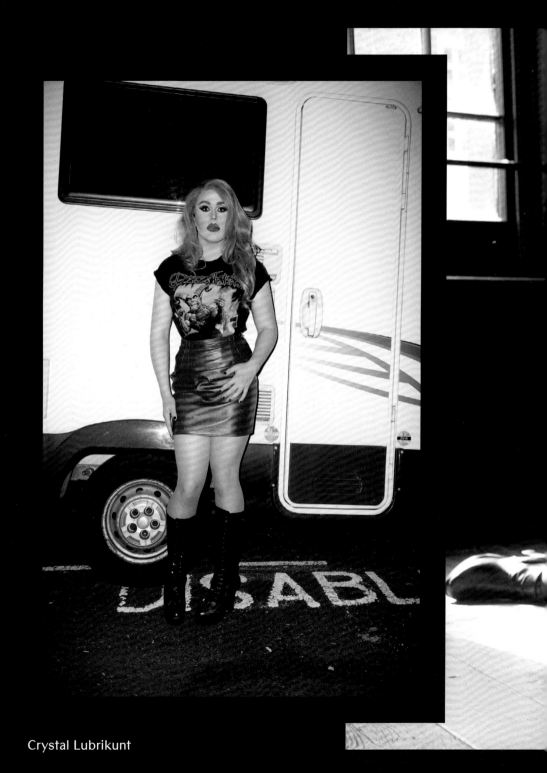

Crystal Lubrikunt

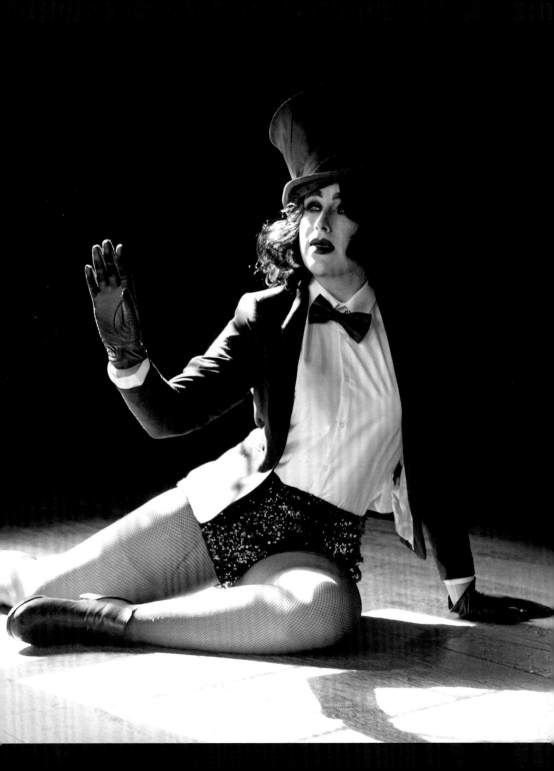

"Meet and greets should be like a buffet.

Don't be the asshole
that holds up the line,
thinking of which
piece of bacon
is the perfect piece.
Grab a handful and go.
If everyone has been served,

GO BACK
FOR SECONDS."

Darienne Lake

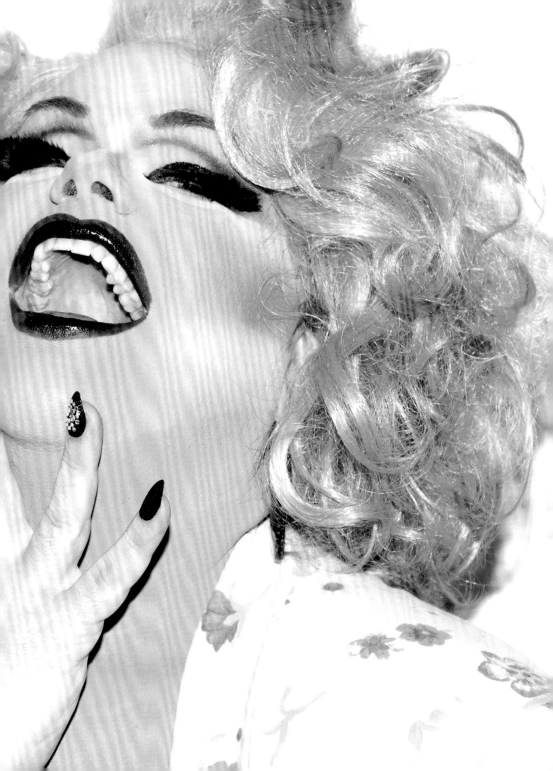

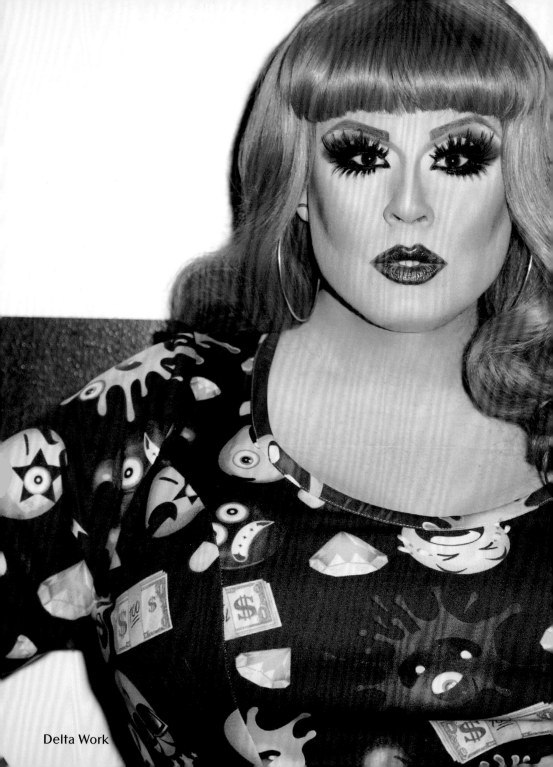

Delta Work

"I believe most of my idiosyncrasies come from the fact that I am an Aquarian, an only child, and was raised by a single parent.

People think I am picky but I am really just particular.

PEOPLE THINK
I THROW
SHADE
BUT I REALLY
JUST
SHED
LIGHT."

Detox

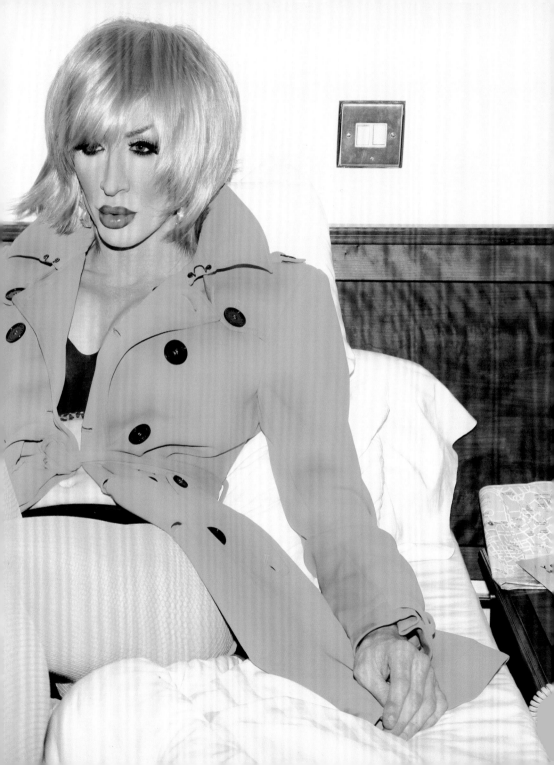

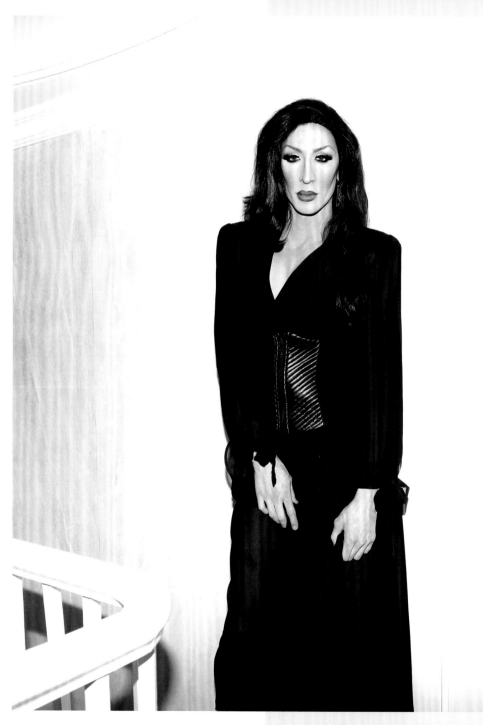

Detox

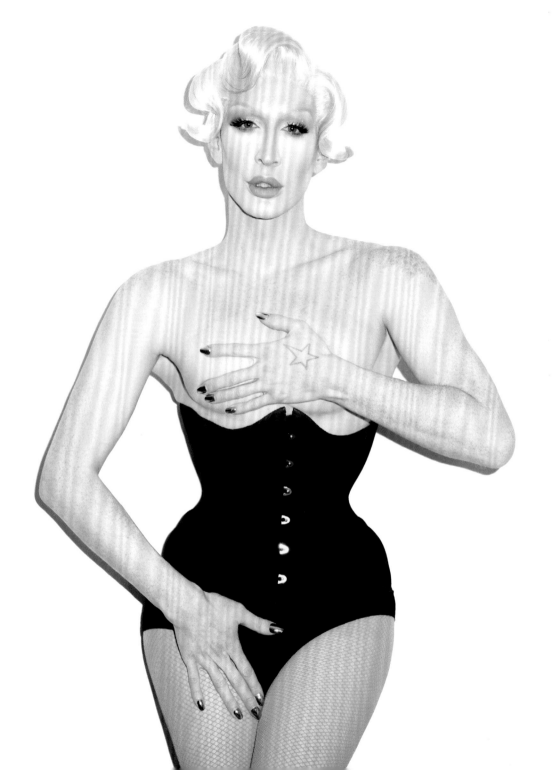

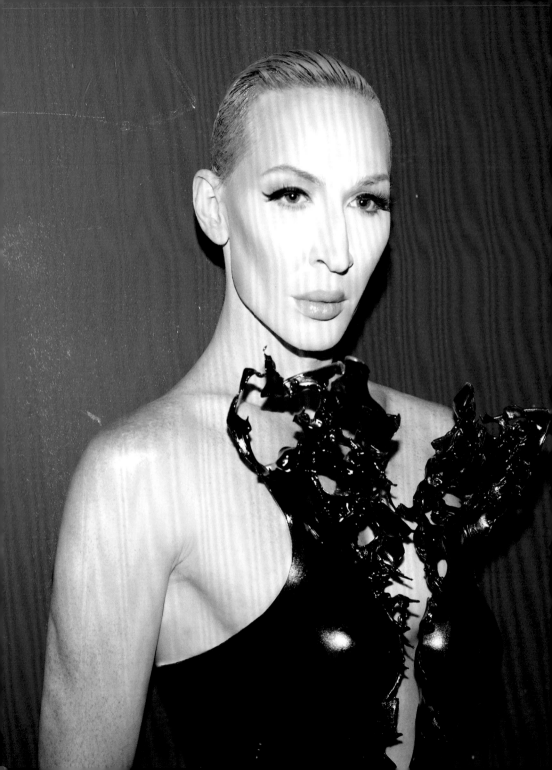

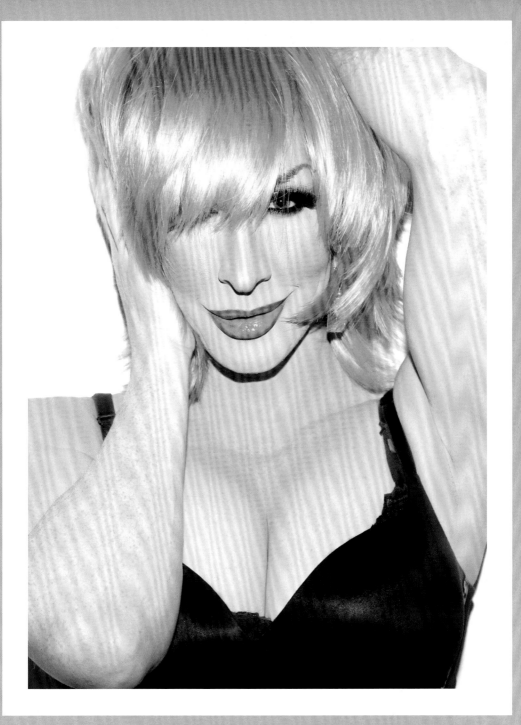

Detox

Disasterina

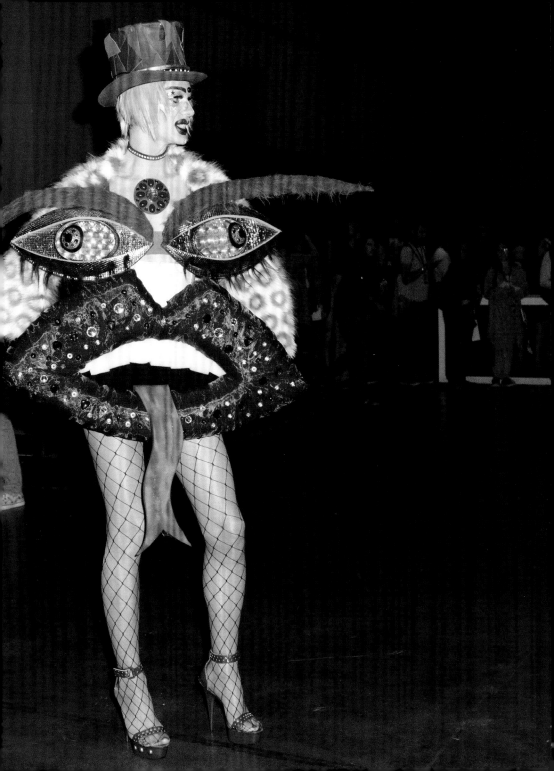

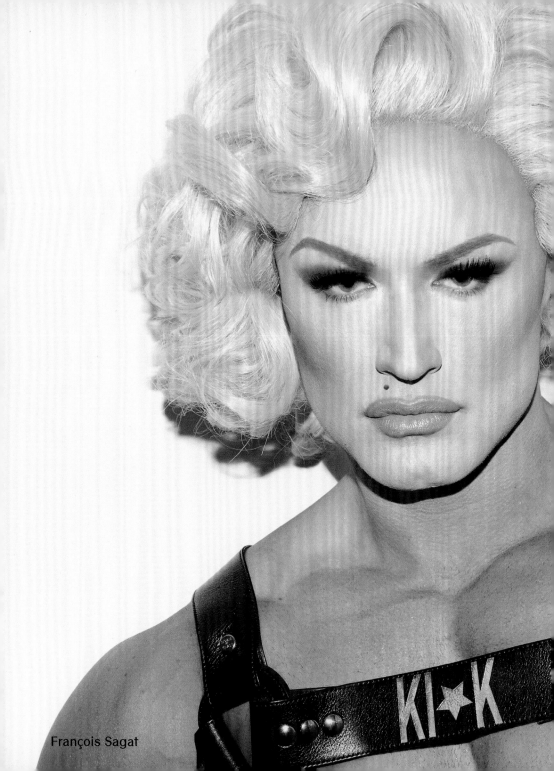

François Sagat

"Drag, in all its forms,
is my number one fantasy.
I've been everything from
a '90's dominatrix
to a high-heeled zombie,
a '50's pin-up
to a glamorous reptilian alien.
Next, I want to be
a Gothic Barbie doll.
THAT'S WHAT DRAG IS …

BIGGER THAN LIFE!"

François Sagat

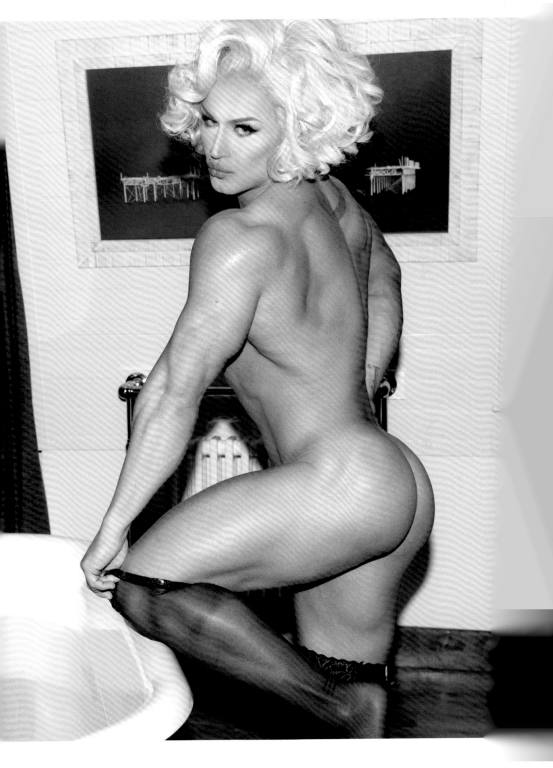

"MY ONE-TIME EXPERIENCE IN DRAG MADE ME REALIZE THE DEPTH AND COMMITMENT THE **REAL QUEENS** GO THROUGH."

Frankmusik

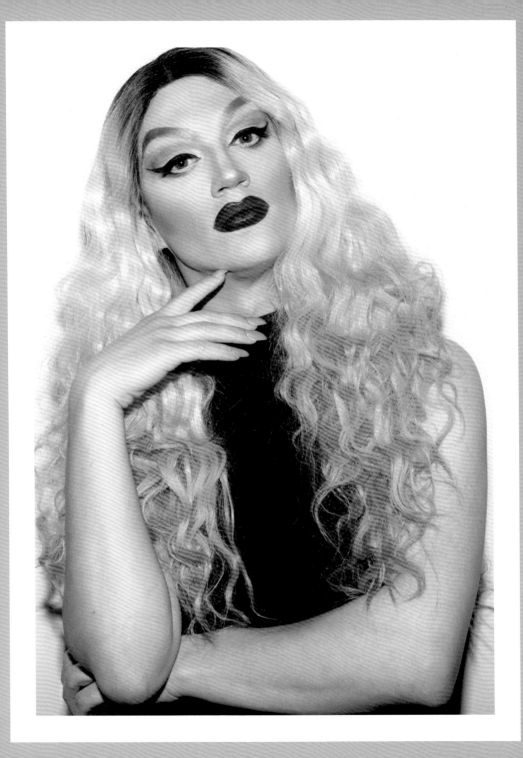

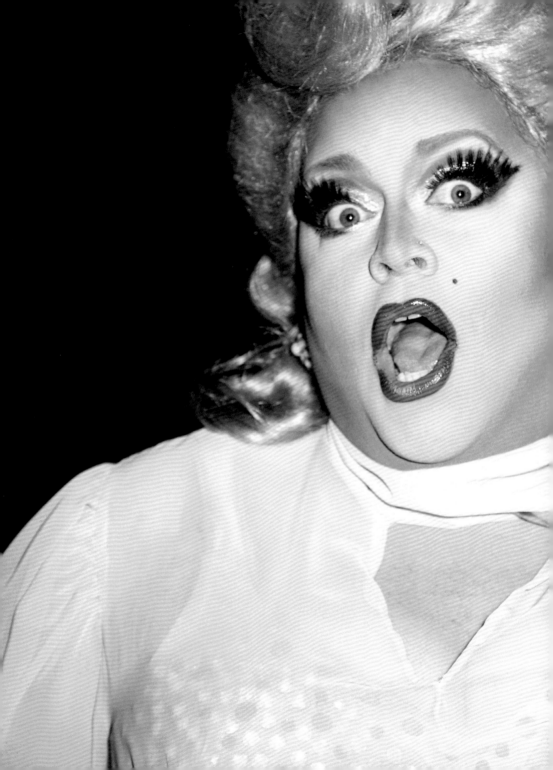

Ginger Minj

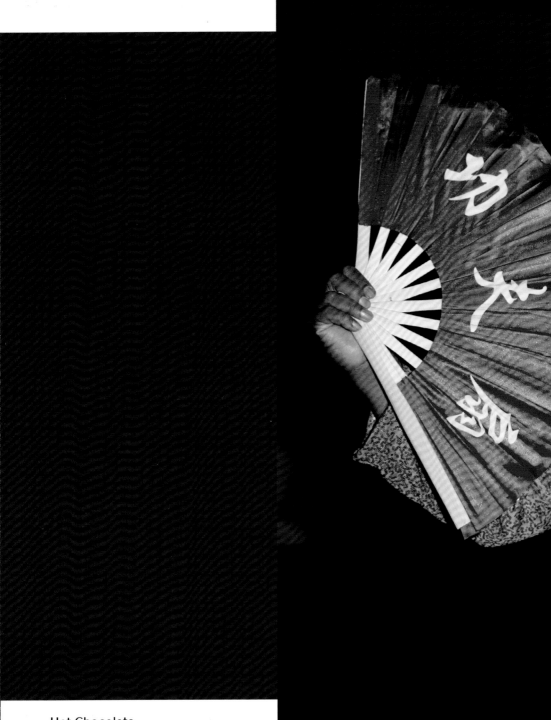

Hot Chocolate

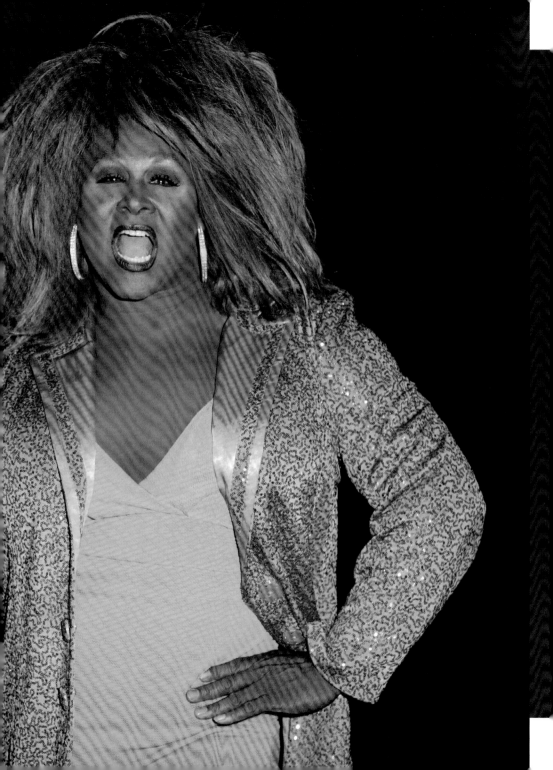

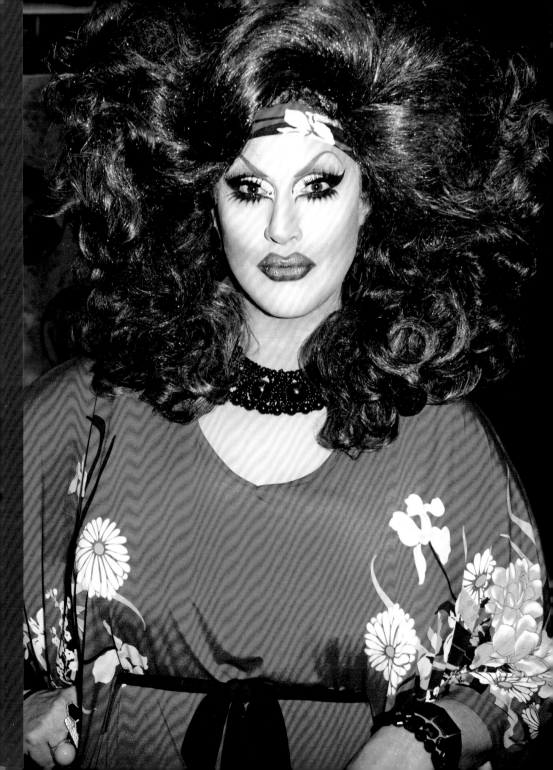

"I always tell people
'LIFE IS EMBARRASSING
IF LIVED PROPERLY.'
In other words, if you don't
have at least a few photos
of yourself in a ridiculous
hairstyle or outfit —
that seemed like
a great idea at the time,
but now looks hilarious —
then you're playing it
WAY
TOO
SAFE."

Jackie Beat

"It's astounding
how much you can
learn about yourself
while doing drag.
You learn to embrace
your creativity,
 YOUR UNIQUENESS,
every single part
of yourself including
your faults."

Jade Jolie

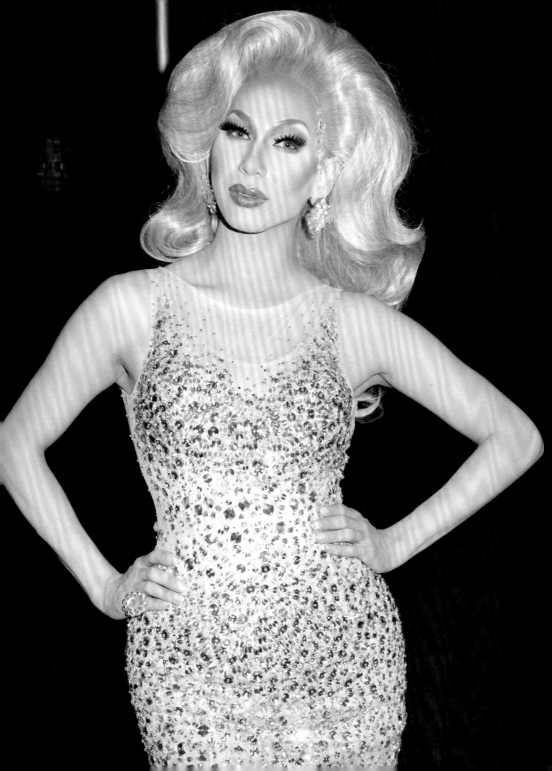

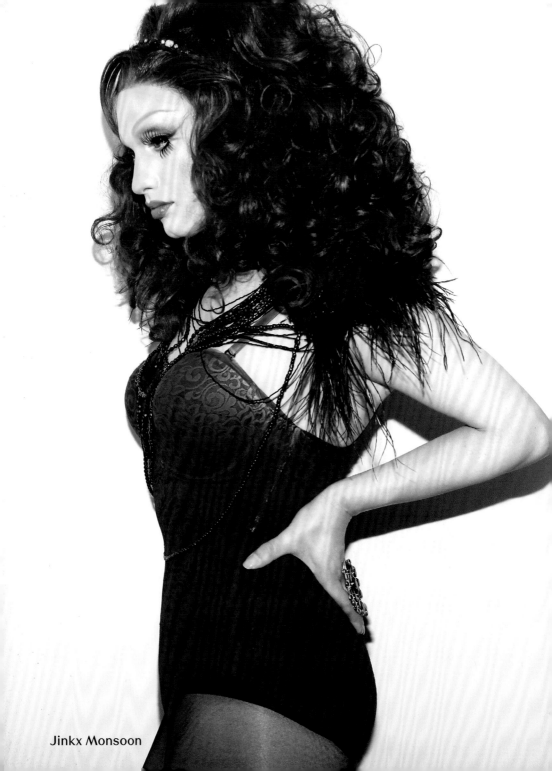

Jinkx Monsoon

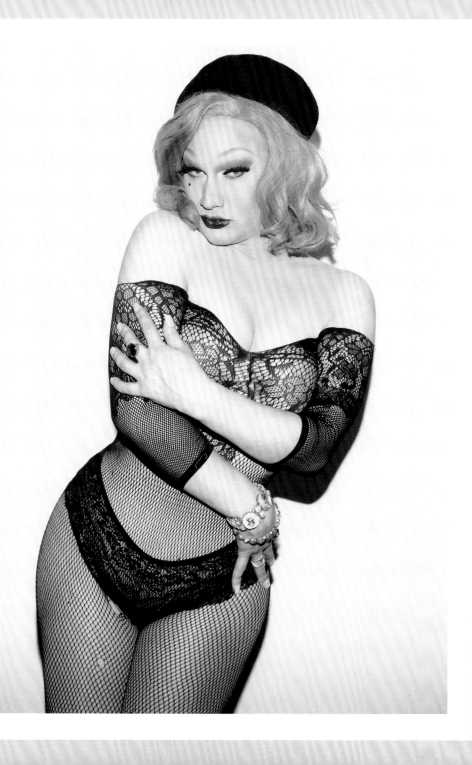

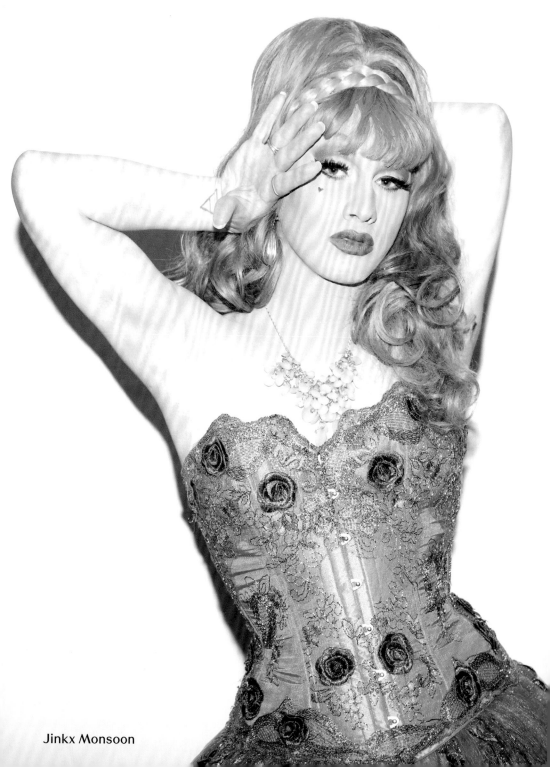

Jinkx Monsoon

"Jinkx is a character.
She is a real woman
who tried to make it in theatre
but never did, so she took
all of her theatre know-how
and went and auditioned
in a dingy little bar for a cabaret show,
not realizing it was a drag show.
It stuck and that's where
she found her calling,

PERFORMING
FOR DRUNKEN
HOMOSEXUALS."

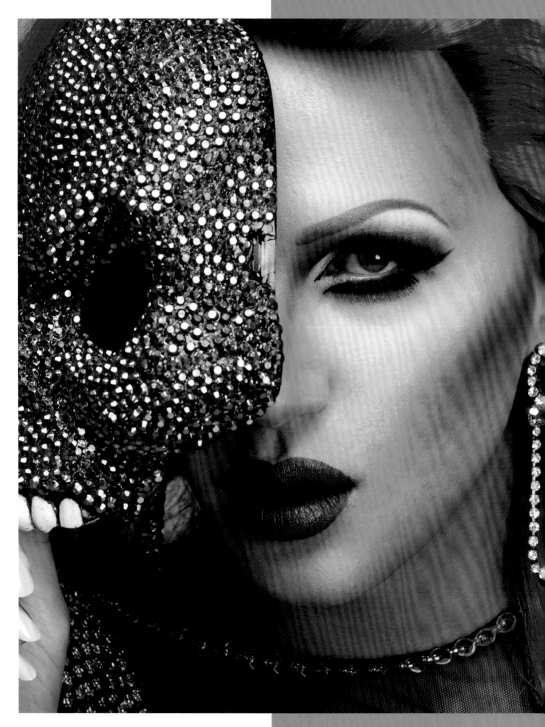

Jodie Harsh

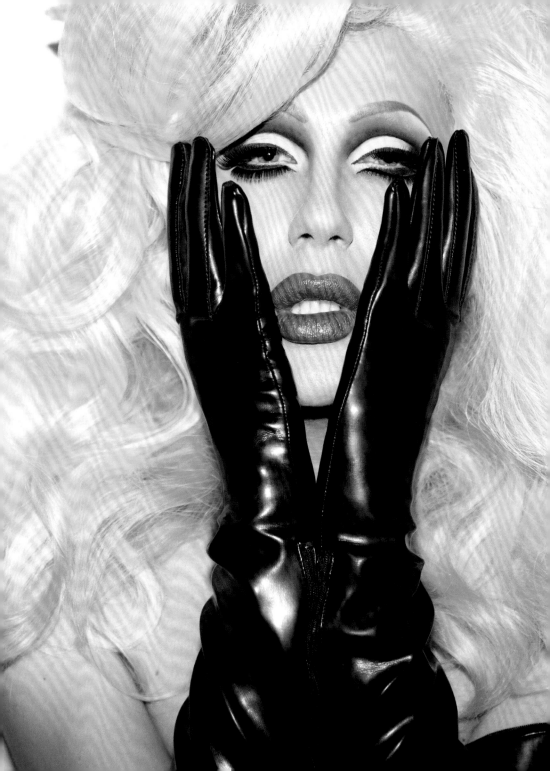

"Drag is my escape and my prison, my work and my play, my joy and my pain, my buzz and my fatigue, my looks and my brains, my business and my pleasure, my laughter and my tears, my boy and my girl. And it hurts my fucking feet."

Jodie Harsh

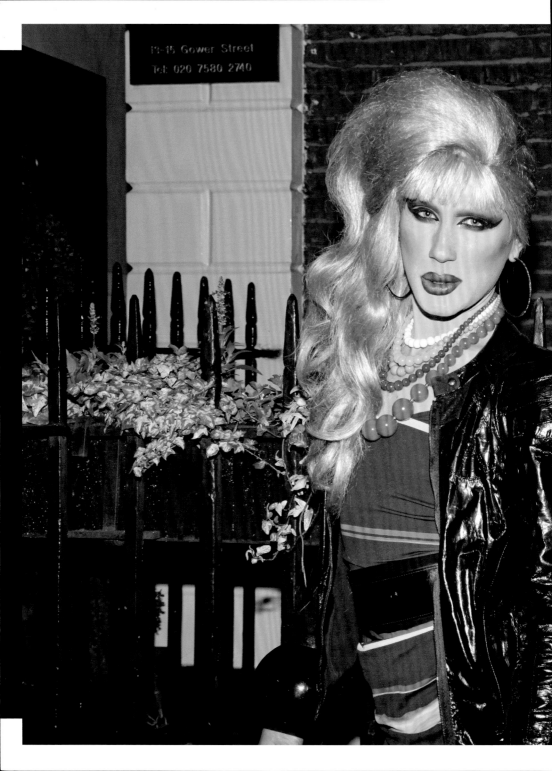

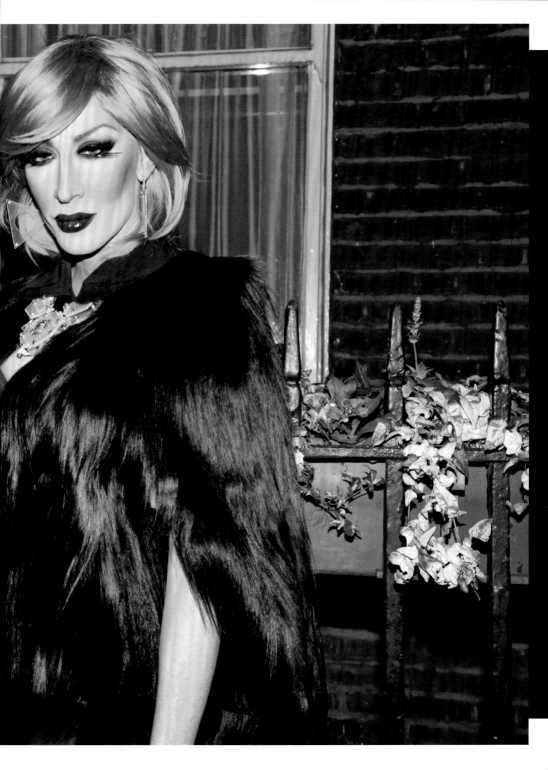

"Drag is inspiration into transformation. You can morph and shape and mould yourself into whatever you want to be. IT'S LIMITLESS."

Joe Black

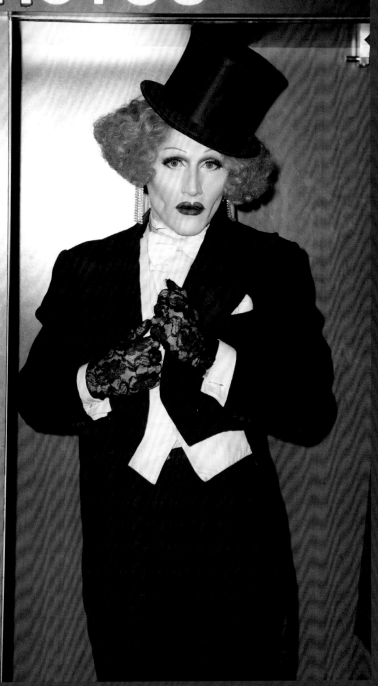

Joe Black

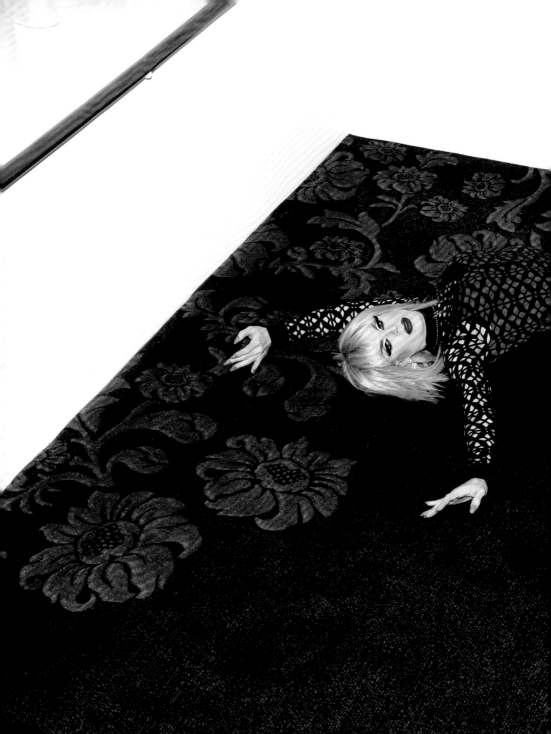

Katya Zamolodchikova

Katya Zamolodchikova

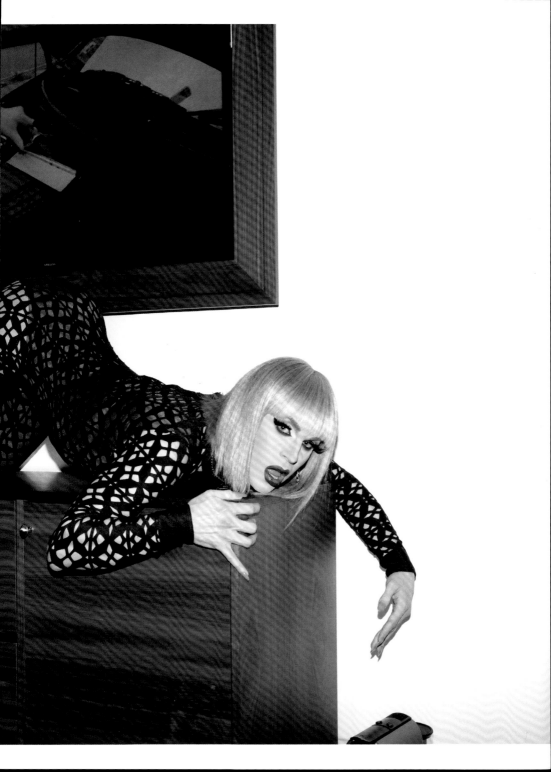

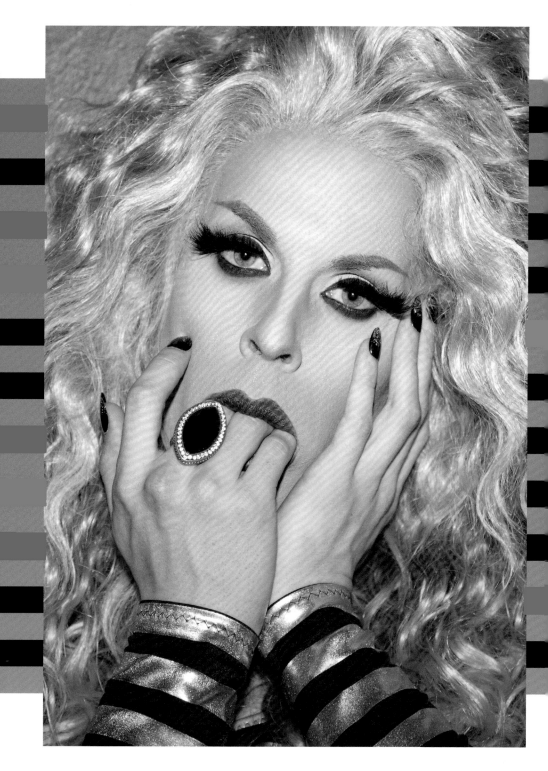

"Everyone talks about drag as if they really know what it's like to cross the raging river of gender and say hello to being a woman. I'm here to tell you they probably don't. But I do, and I don't need to produce notarized documents, certificates or awards (even though I have many) to prove my point.

WHEN I'M IN DRAG I'M A WOMAN —

a fact clear to all blessed with vision — but, more importantly, when I look in the mirror drag allows me to say to myself with at least 70 per cent confidence: 'I'm here, and I'm me, and I want that.'"

Katya Zamolodchikova

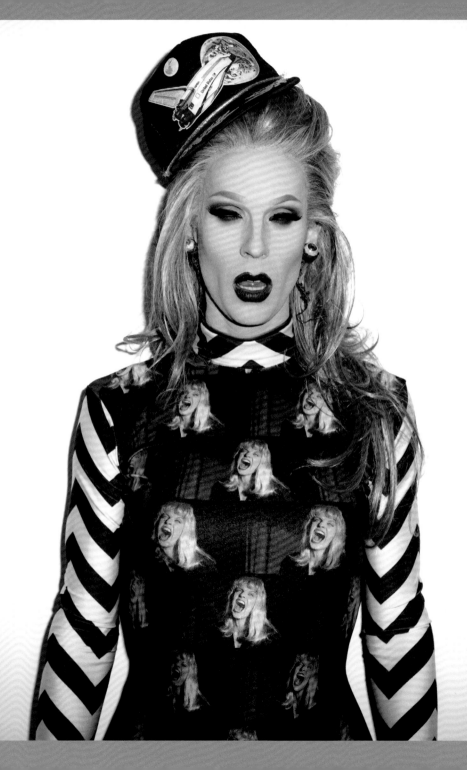

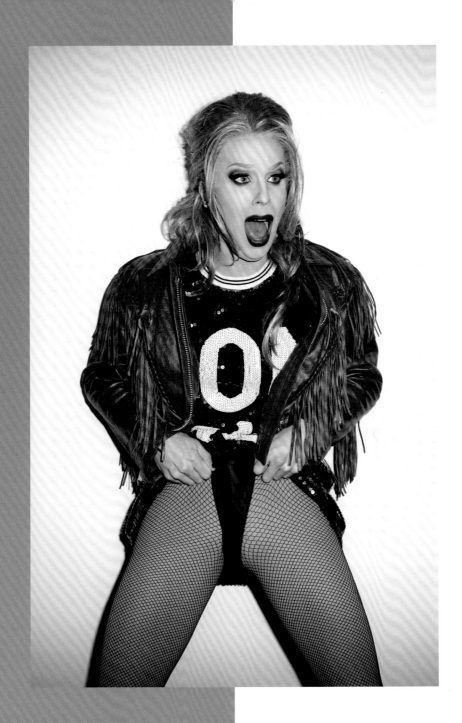

Katya Zamolodchikova

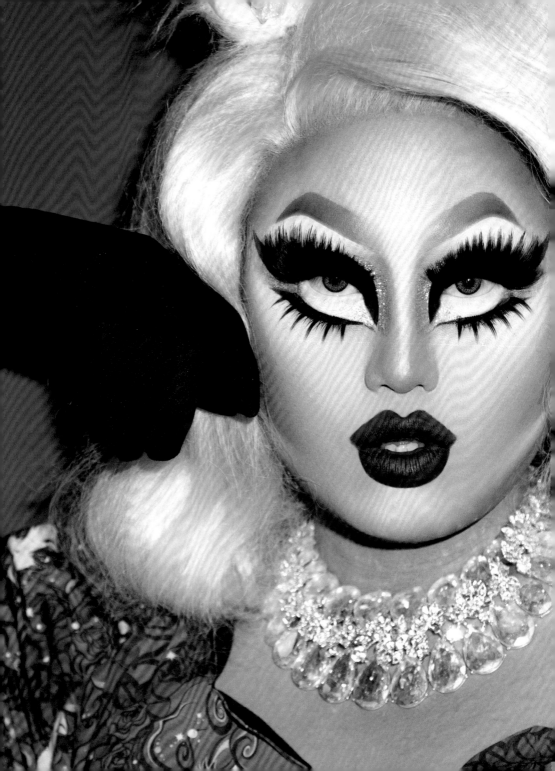

Kim Chi

Kimora Blac

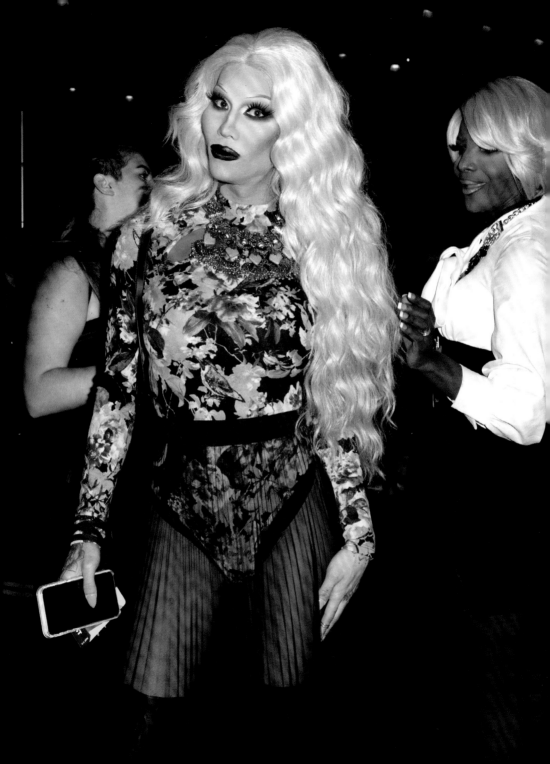

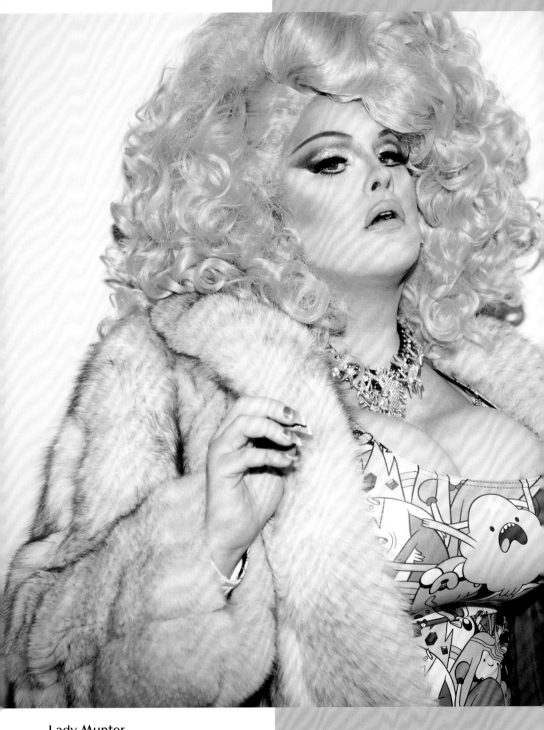

Lady Munter

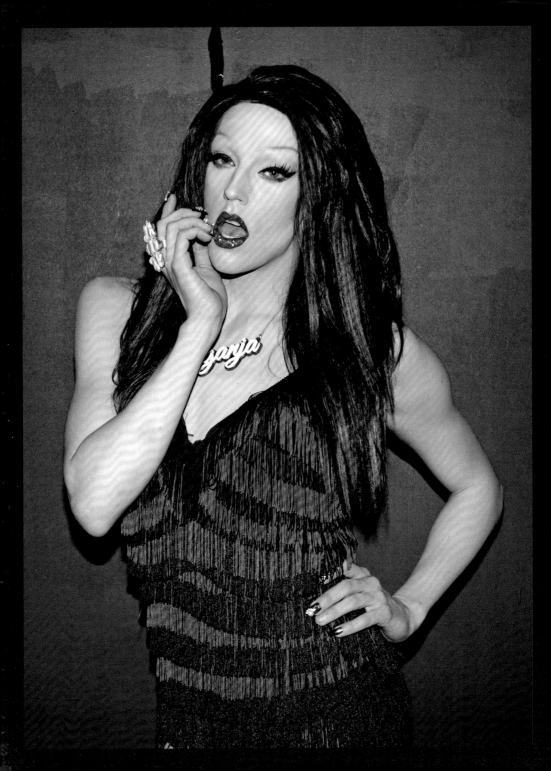

"DRAG IS MORE THAN JUST AN ART FORM, it is a way of life. It's strong, kind, fabulous, loud, rebellious and fierce. I am proud to be a QUEEN and carry myself as one for my community."

Laganja Estranja

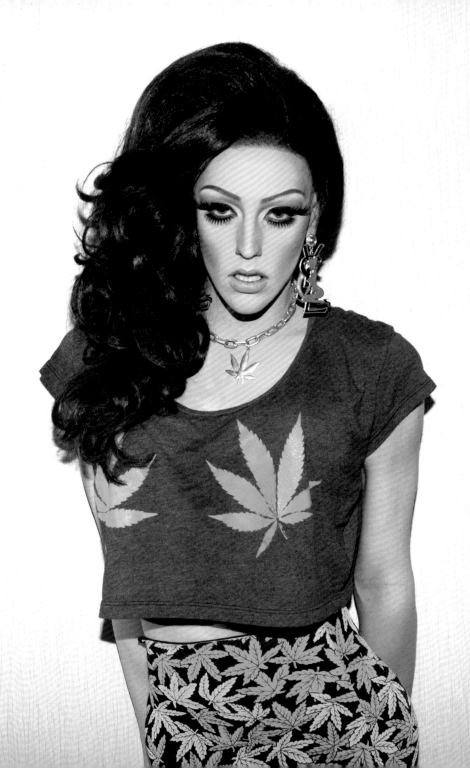

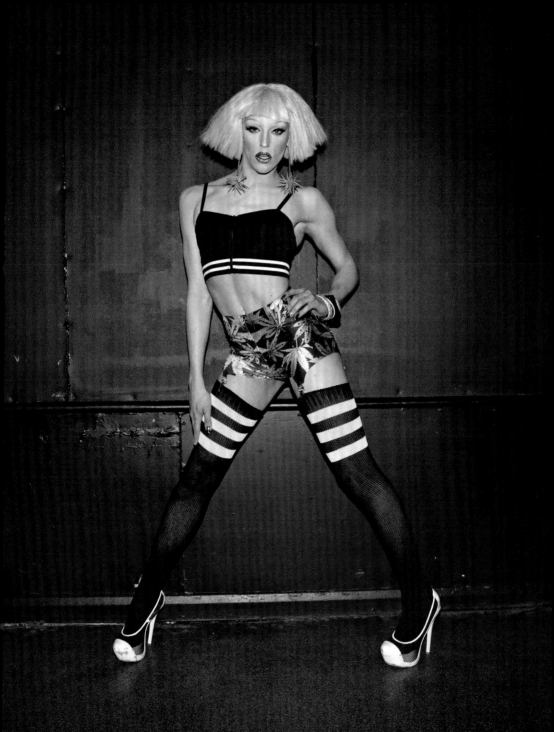

Laganja Estranja

Laganja Estranja

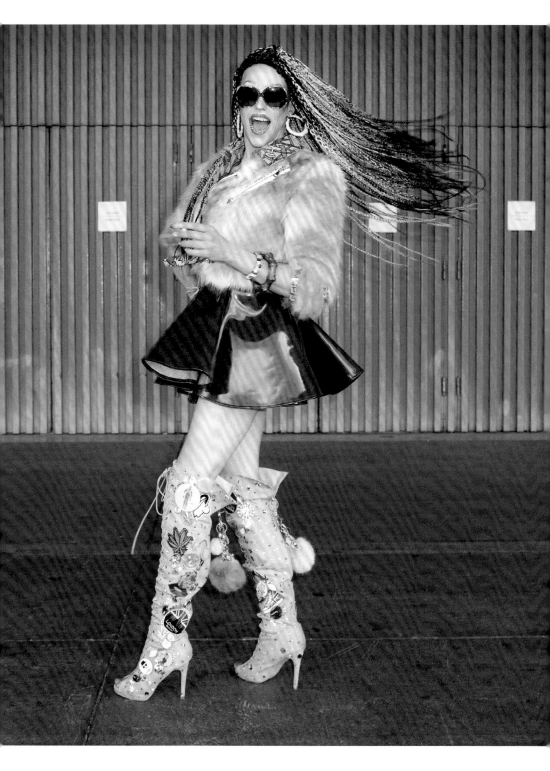

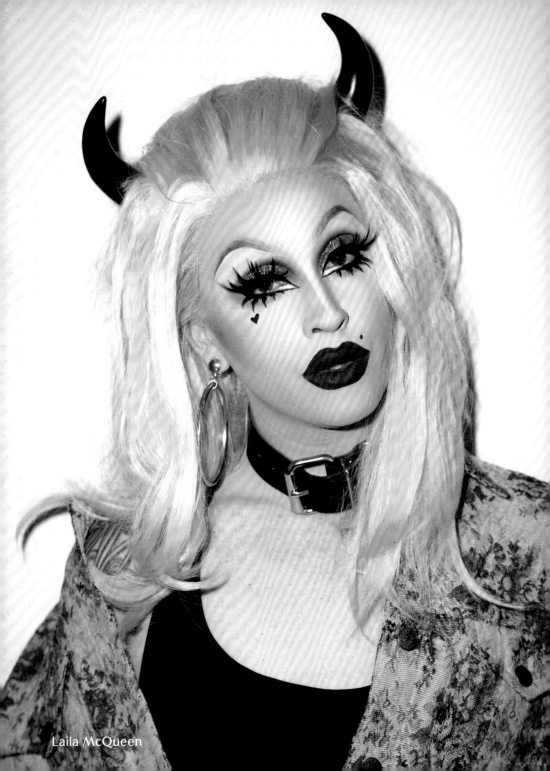

Laila McQueen

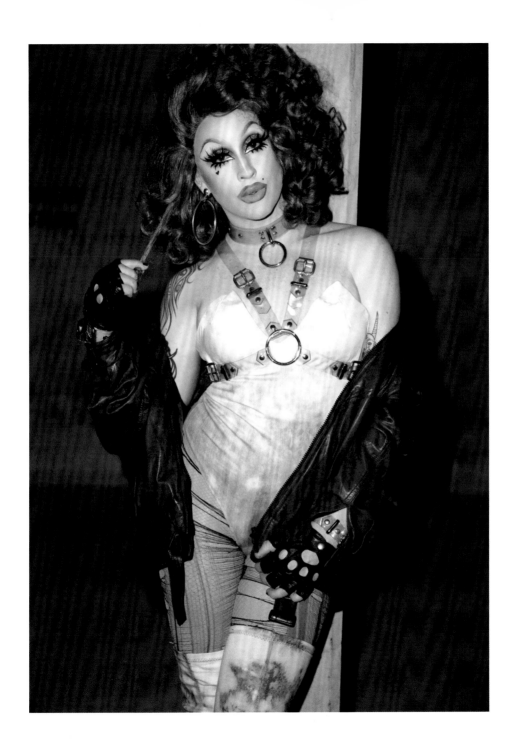

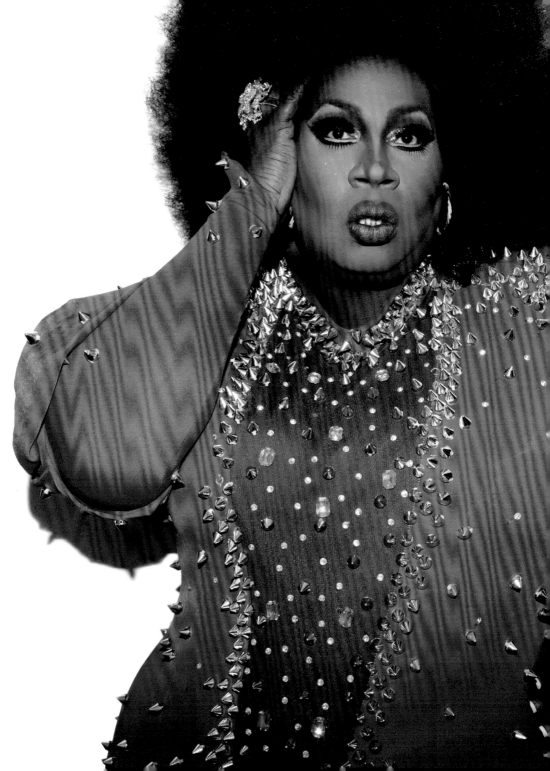

Latrice Royale

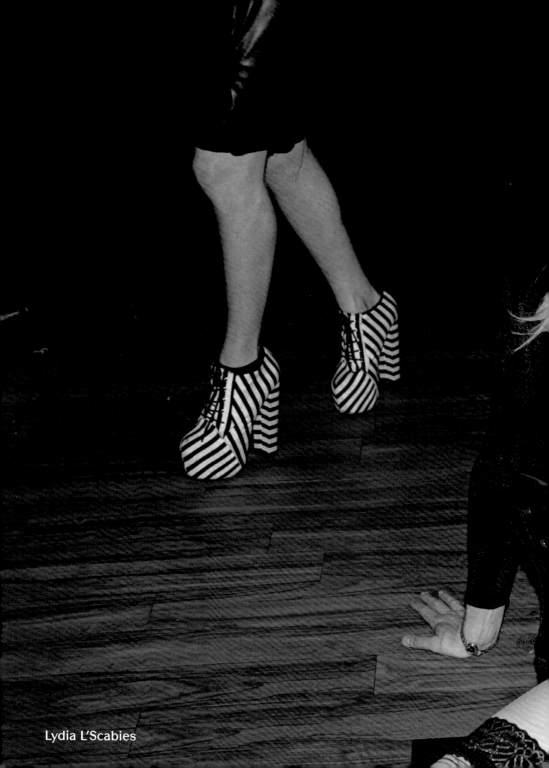

Lydia L'Scabies

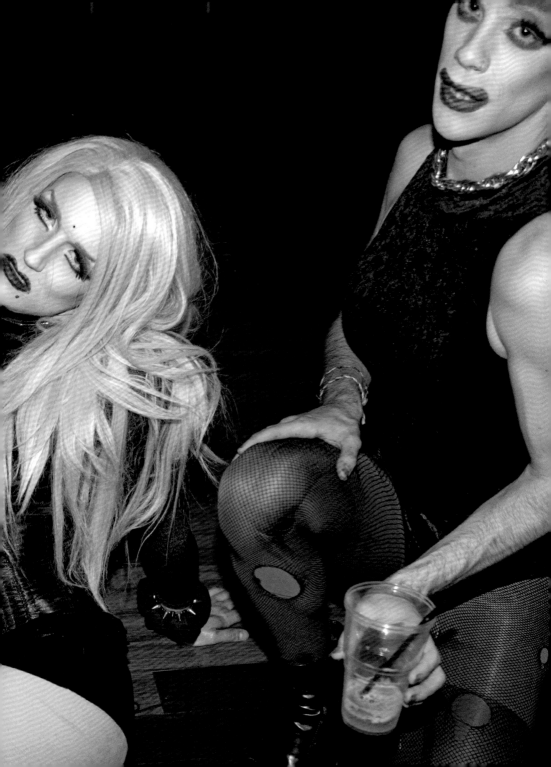

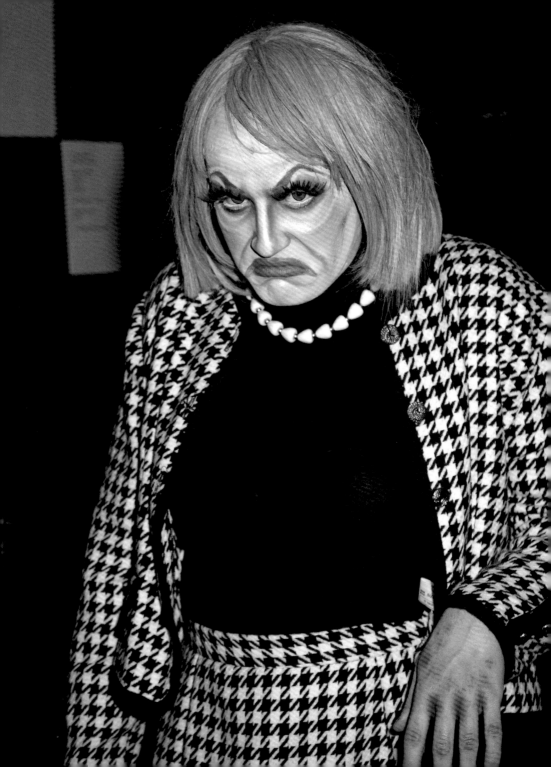

"There are three things I've always said to myself regarding drag: BE DIFFERENT, BE NICE, **DON'T SUCK!** You can't buy stage presence at the pharmacy."

Lydia L'Scabies

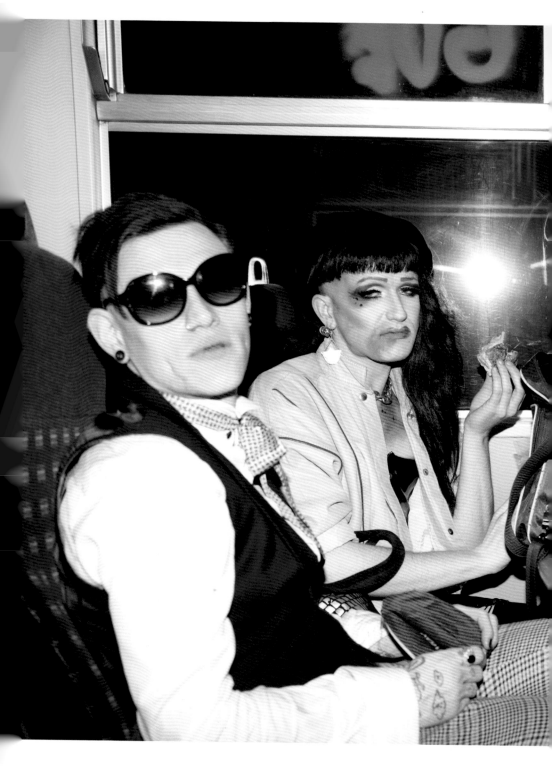

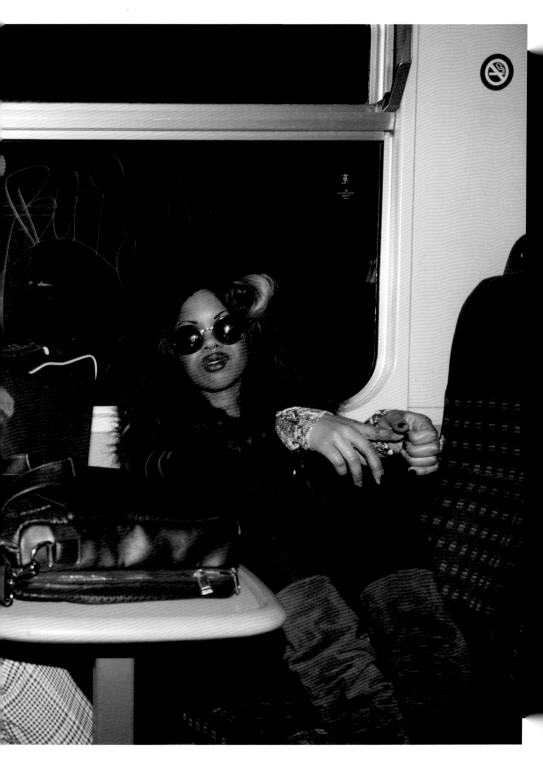

Manila Luzon

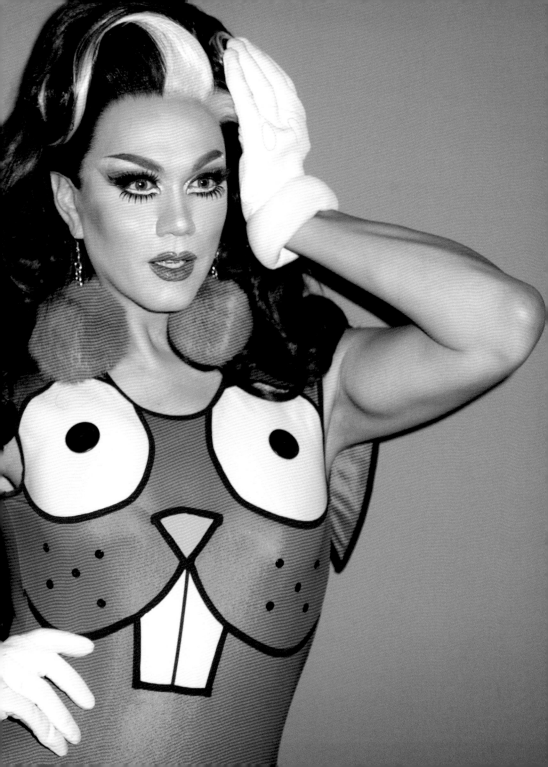

"I straddle the line between

FANTASY

and

REALITY

with a wide stance.
On one side

I AM

the most beautiful,
charming woman on earth,
on the other side

I LOOK

absolutely ridiculous,
trying to stuff my nuts
back into my panties!"

Manila Luzon

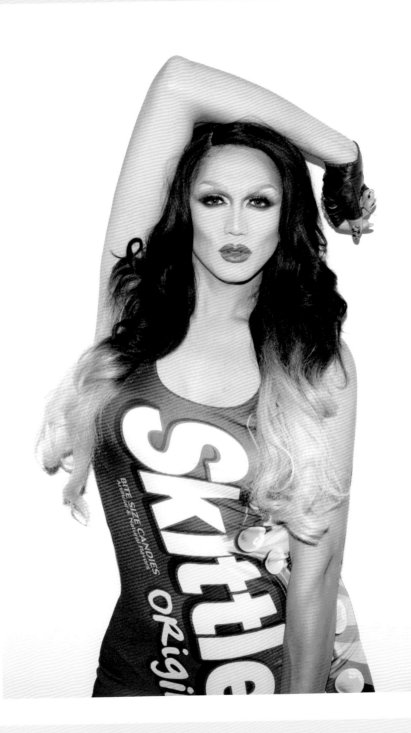

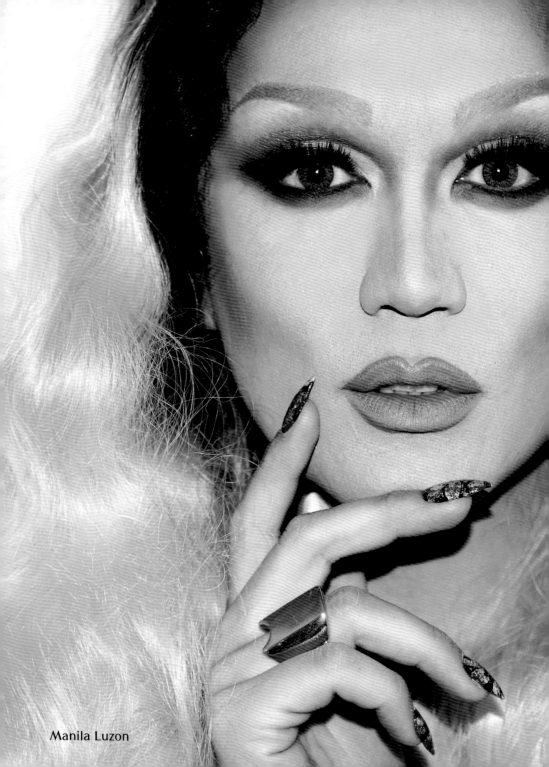

Manila Luzon

Mariah Paris Balenciaga

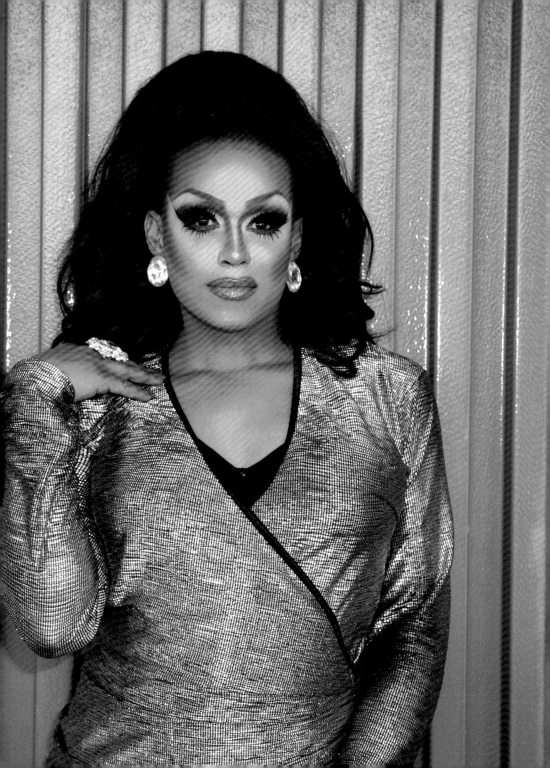

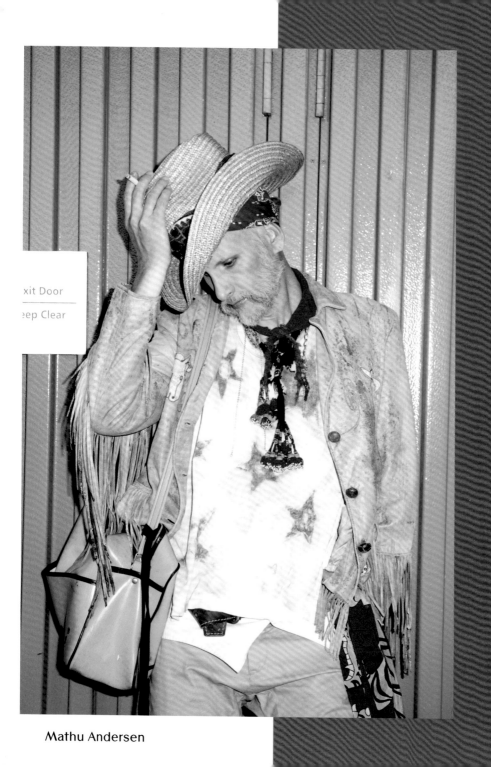

xit Door

eep Clear

Mathu Andersen

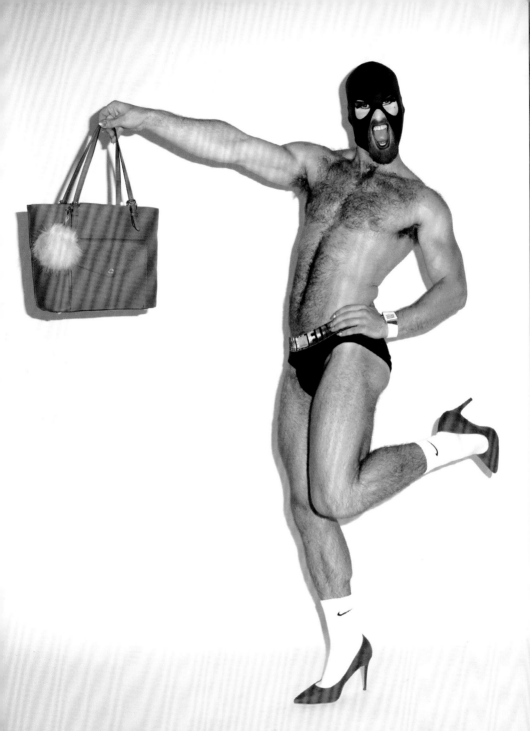

Matt Lister

Max

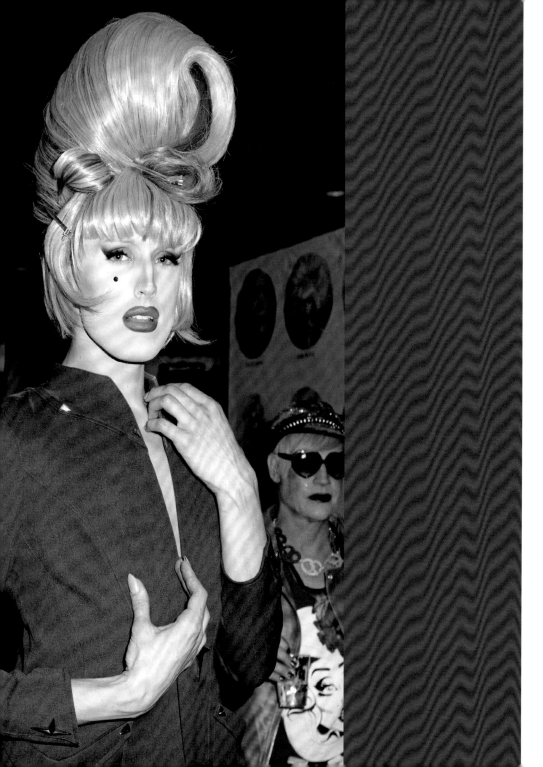

Maxi More

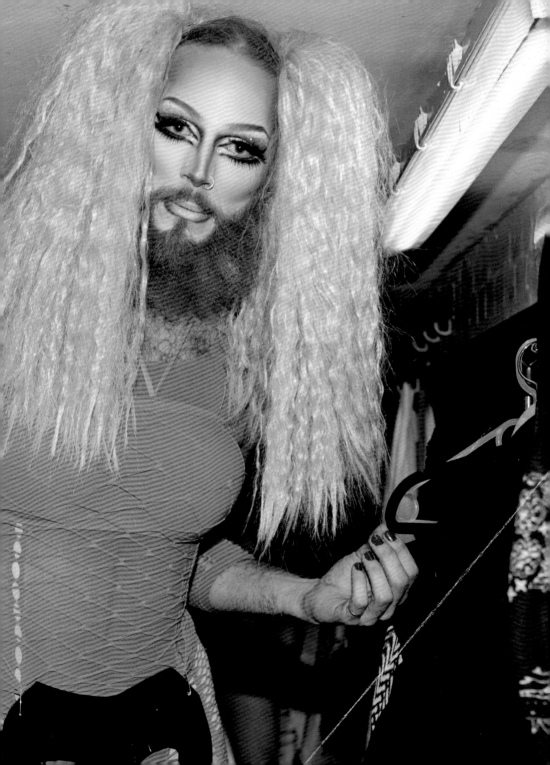

Meth

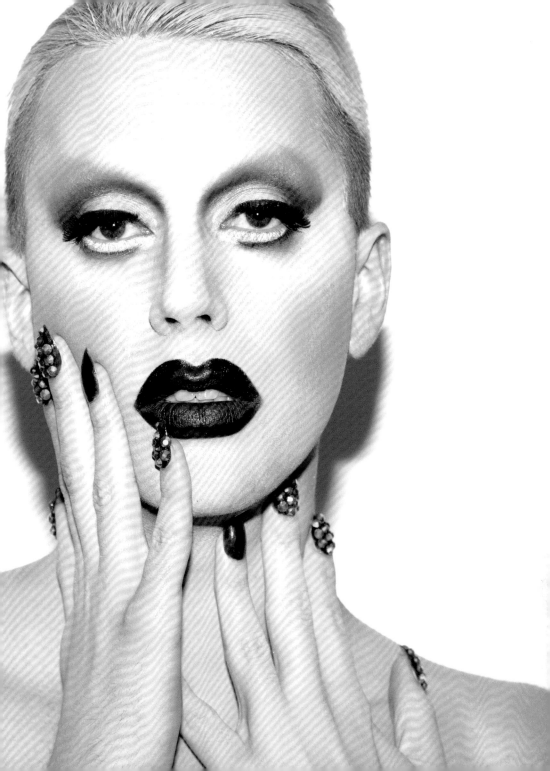

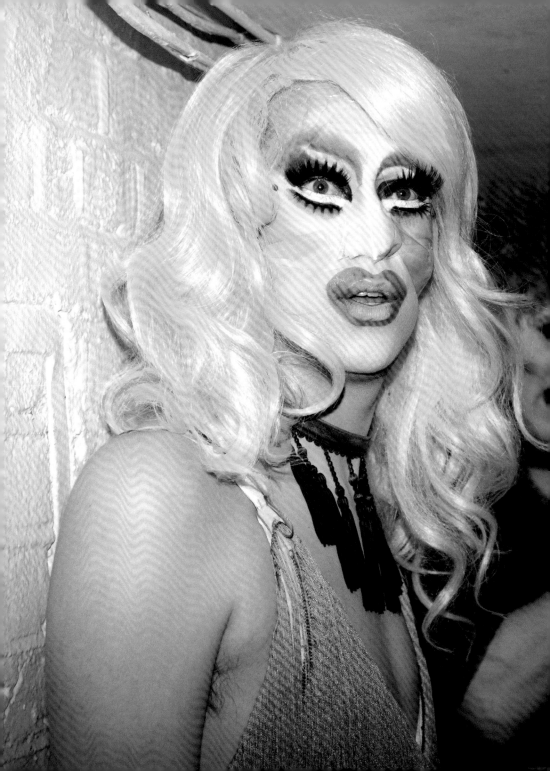

Meth

Meth

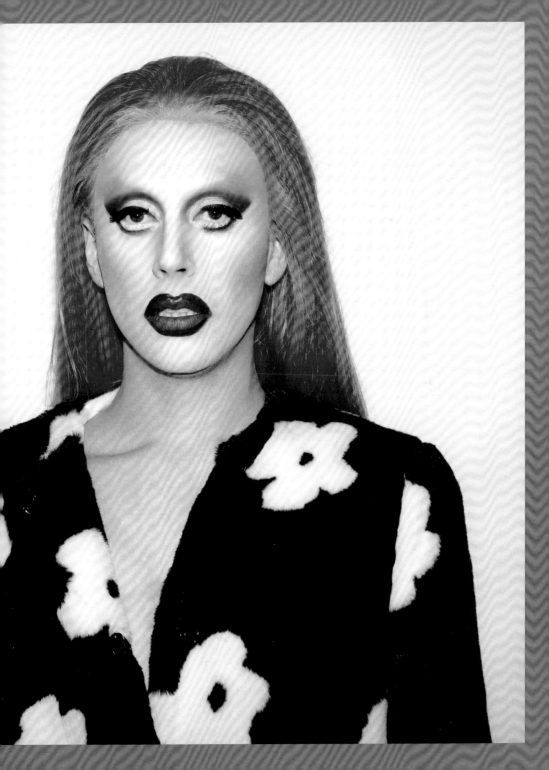

Milk

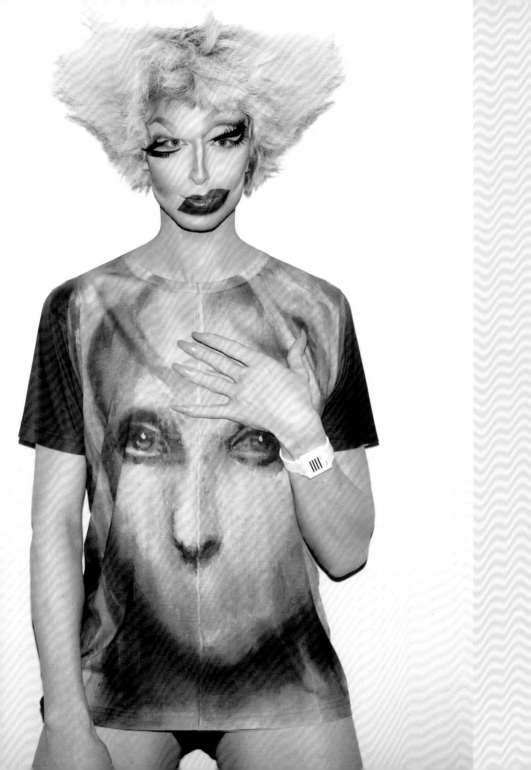

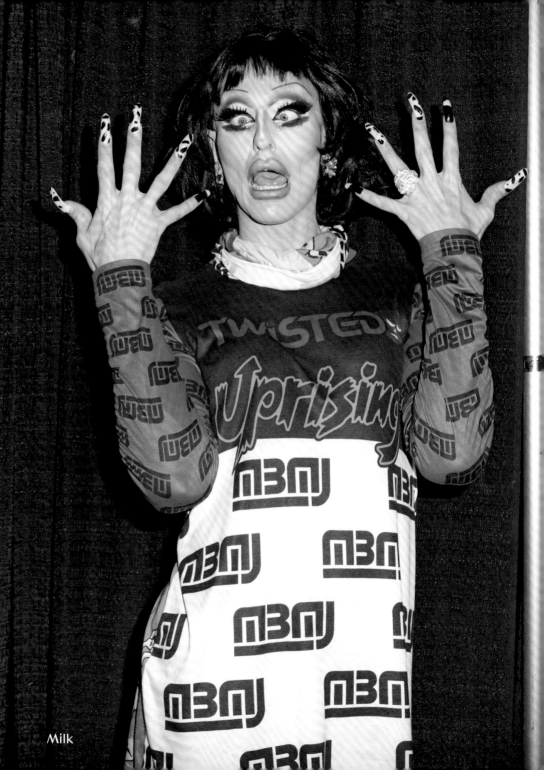

Milk

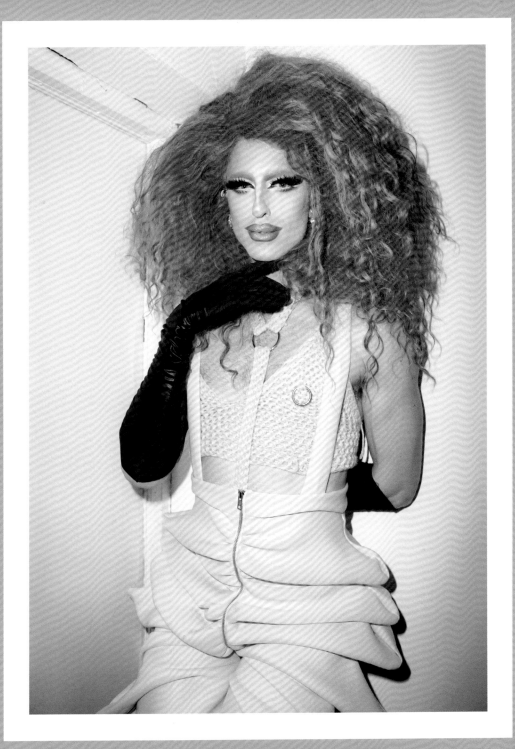

Milk

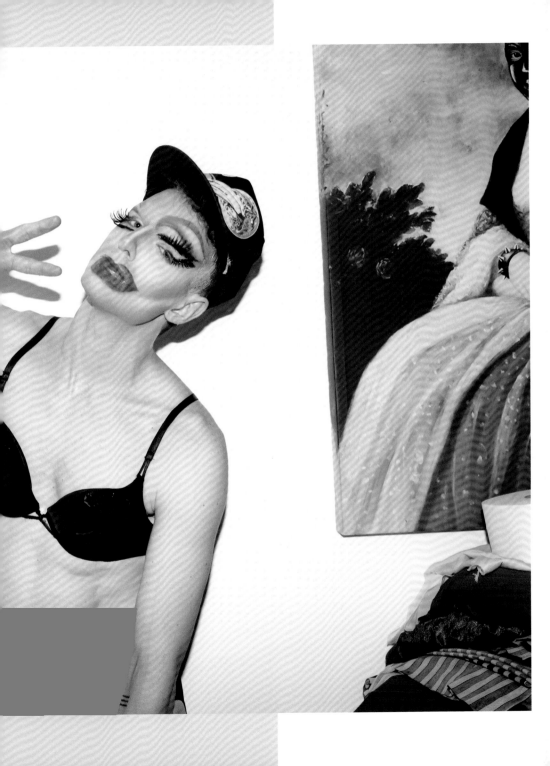

Miss Fame

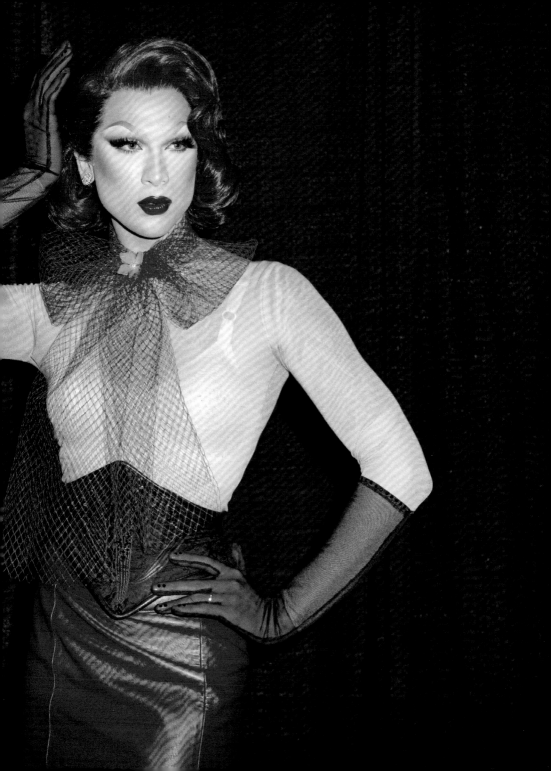

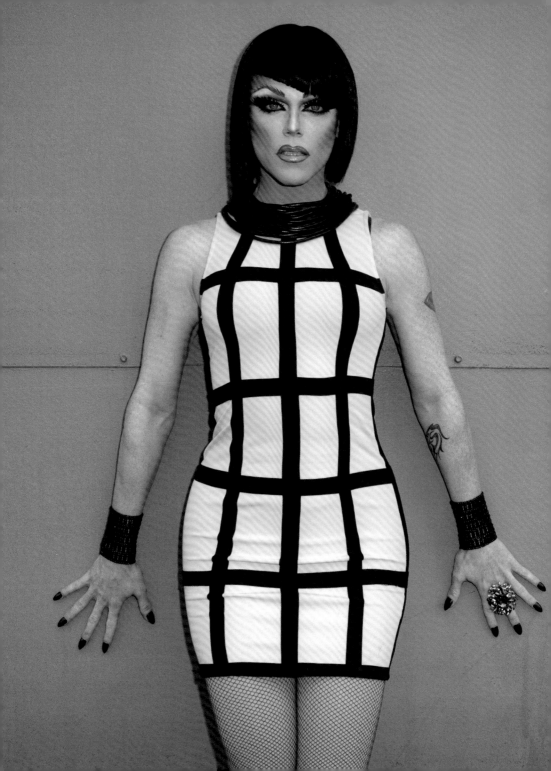

Morgan McMichaels

"I want to be just like grandma, but I realized that was impossible since her gowns were significantly smaller than I'd ever be able to squeeze into. Thank God for the eventual invention of **TWO-WAY STRETCH FABRIC!**"

Mrs Kasha Davis

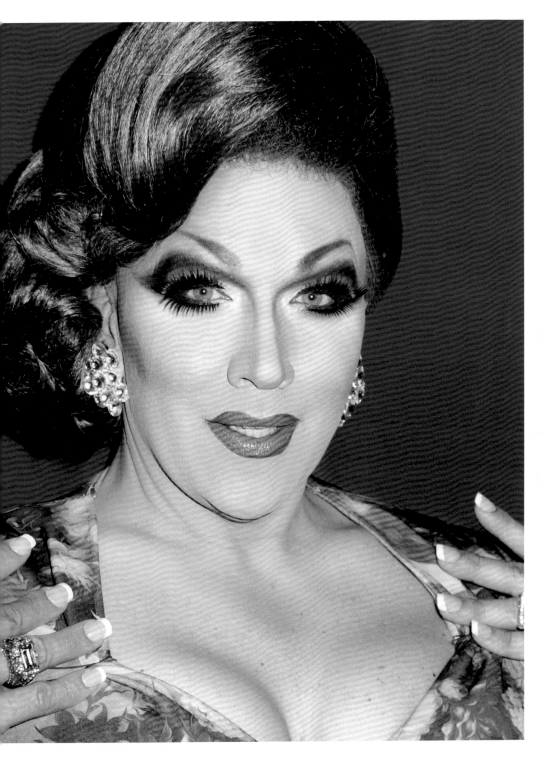

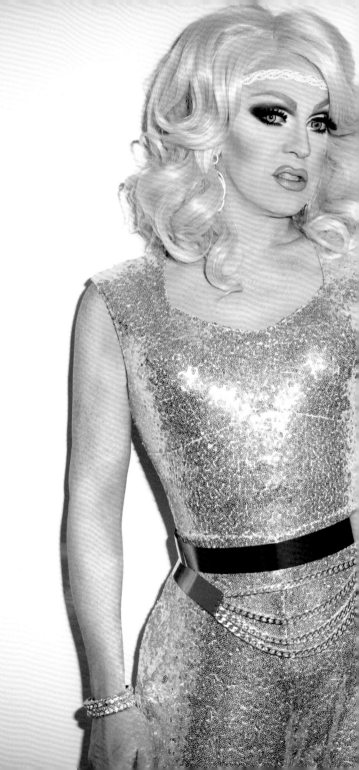

Pandora Boxx

Pearl

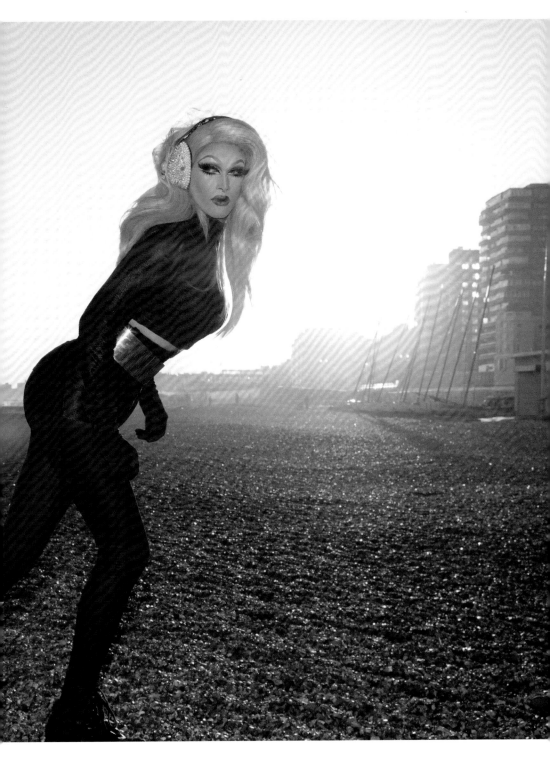

"BEHIND EVERY
ELEGANT,
FAMOUS,

GODDESS-LIKE
DRAG QUEEN

IS THEIR ASSISTANT
WHO KNOWS THE TRUTH."

Pearl

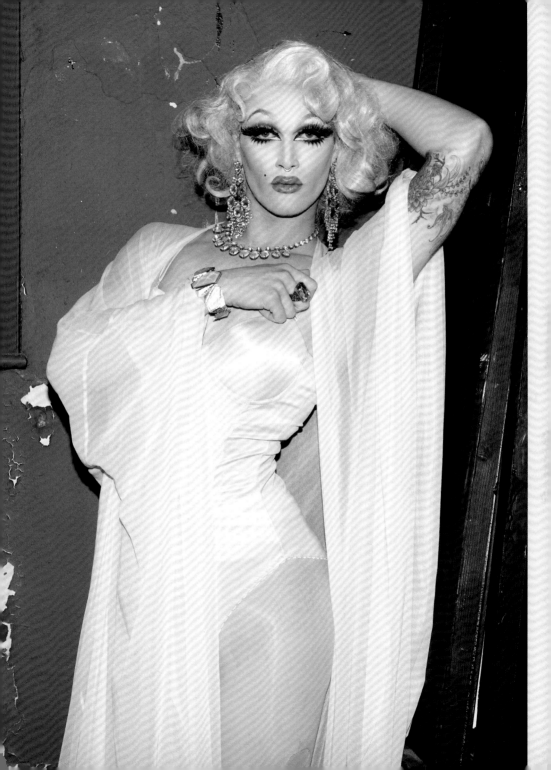

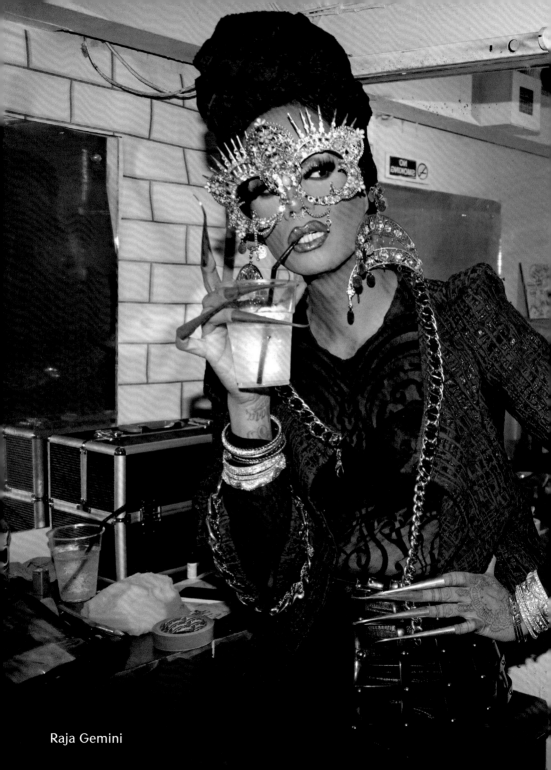

Raja Gemini

"For as long as I've done drag, it's always been about playing with gender — IT'S MEANT TO CONFUSE a little bit."

Raja Gemini

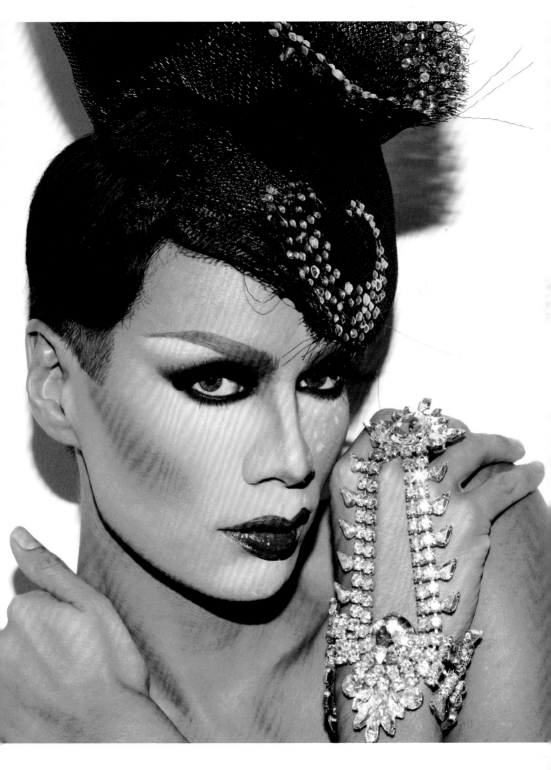

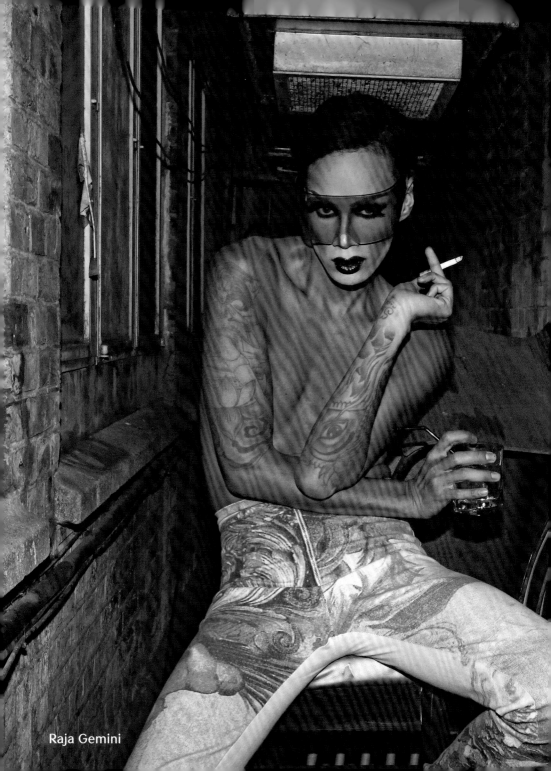

Raja Gemini

"We all embody
 female energy.
 For some it takes on an
 actual physical reality,
 for others it's just
 hip pads and makeup."

Raja Gemini

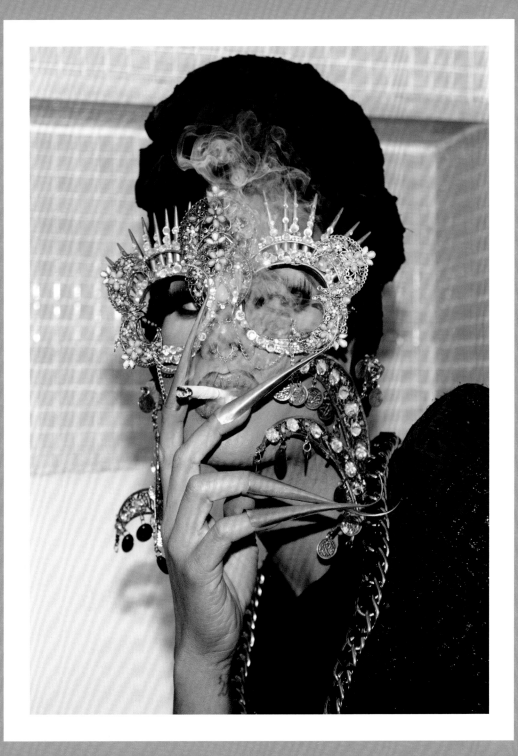

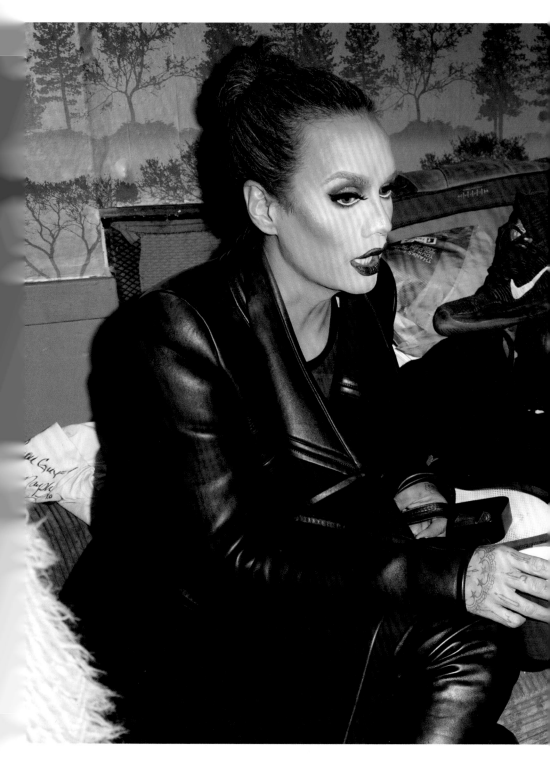

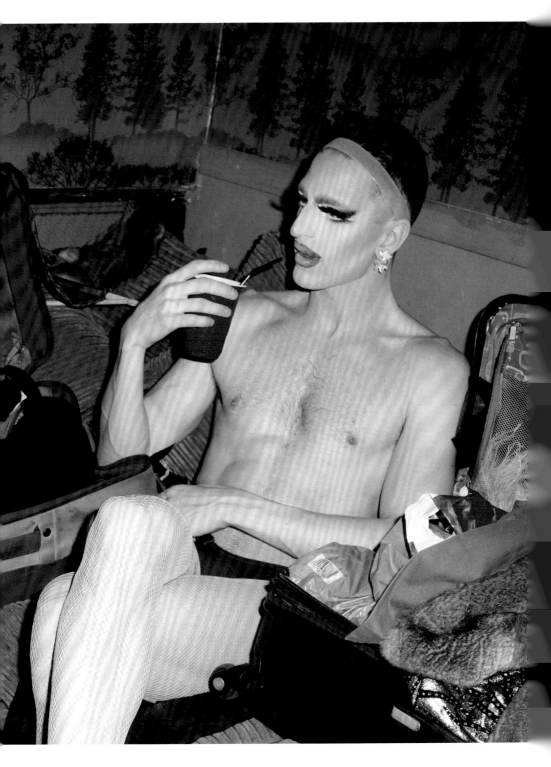

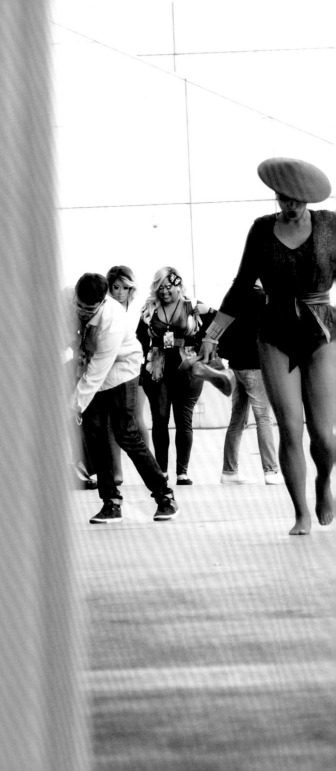

Raven

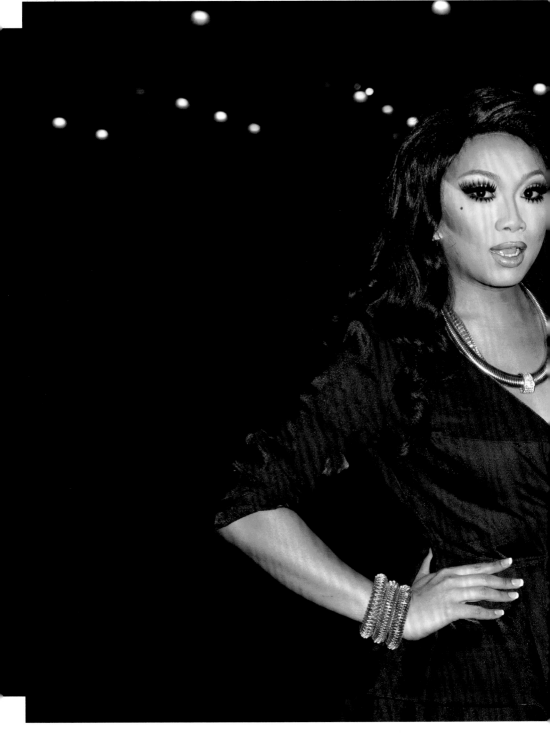

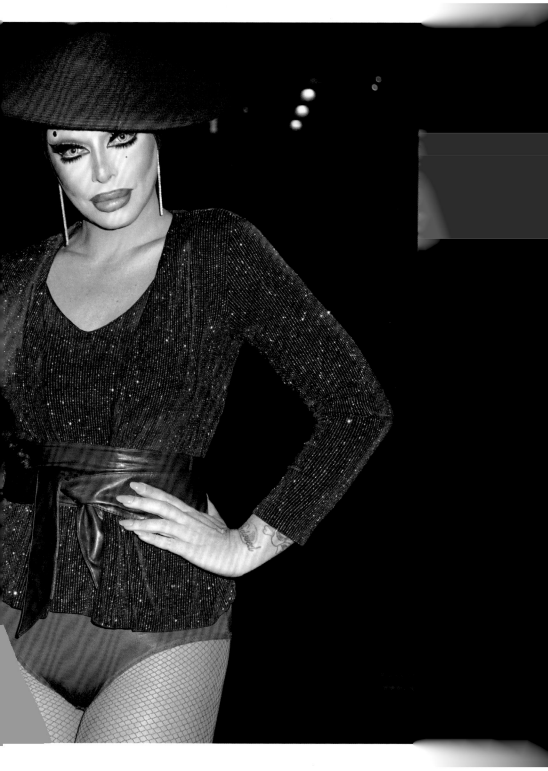

Rhea Litré

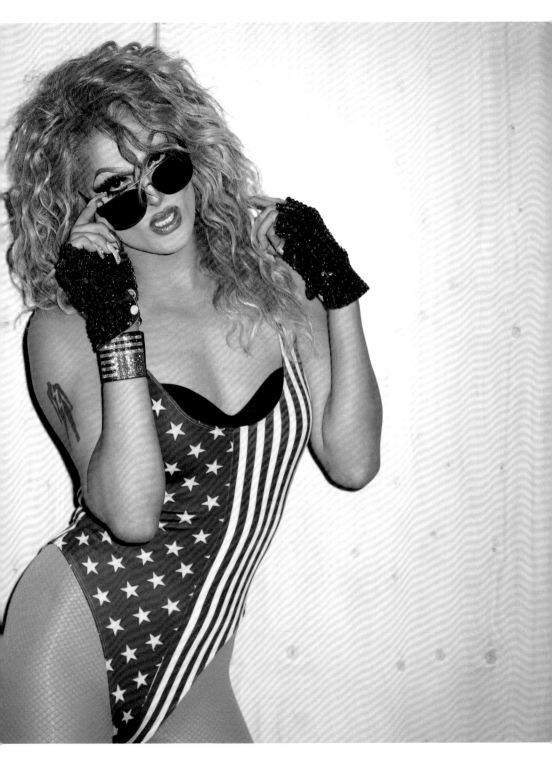

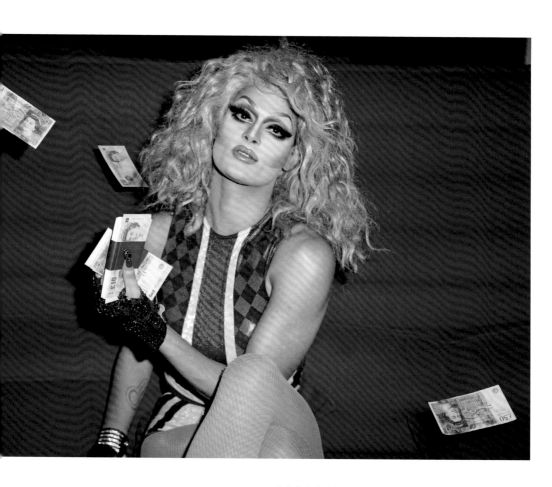

Rhea Litré

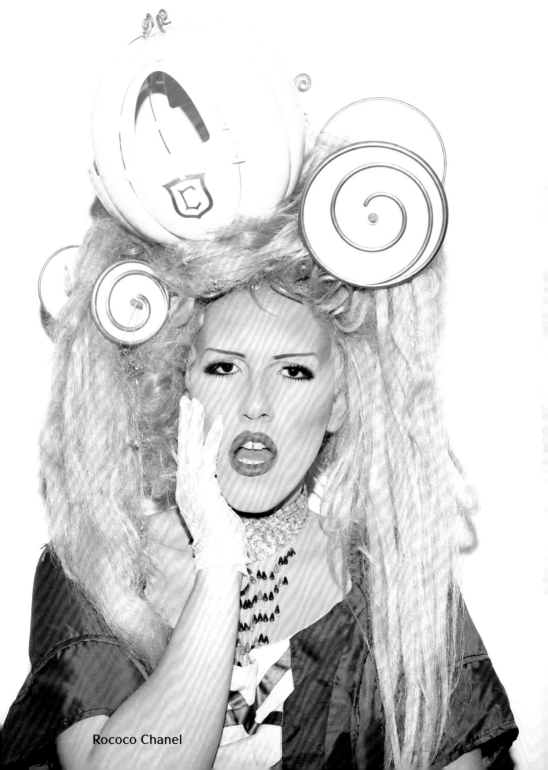

Rococo Chanel

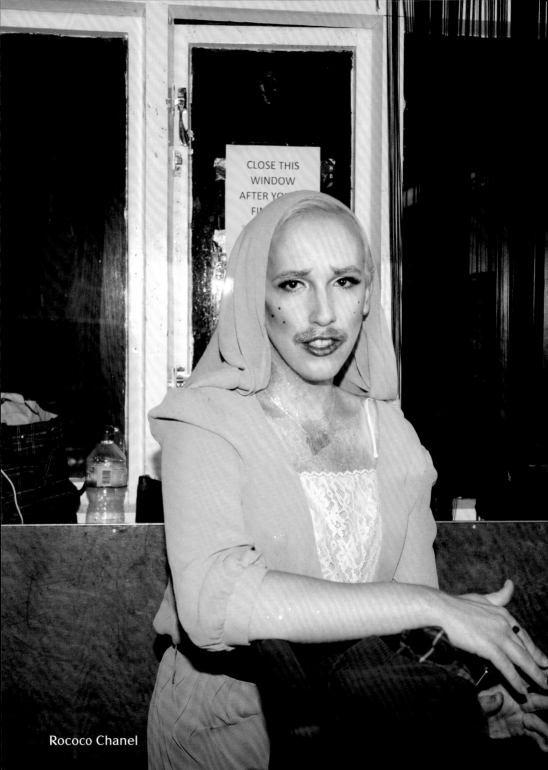

Rococo Chanel

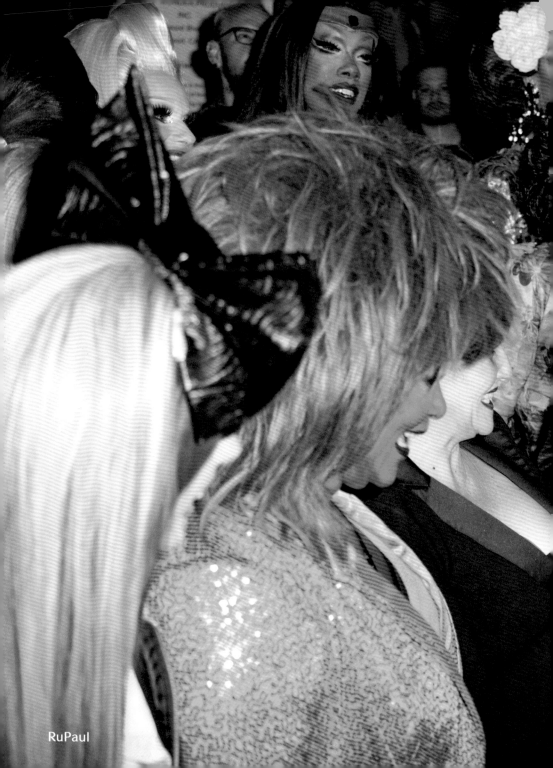

RuPaul

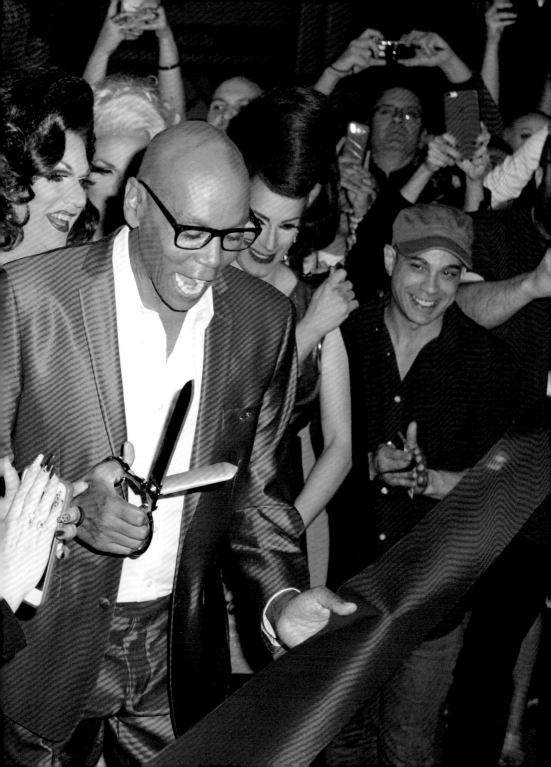

Sasha Velour

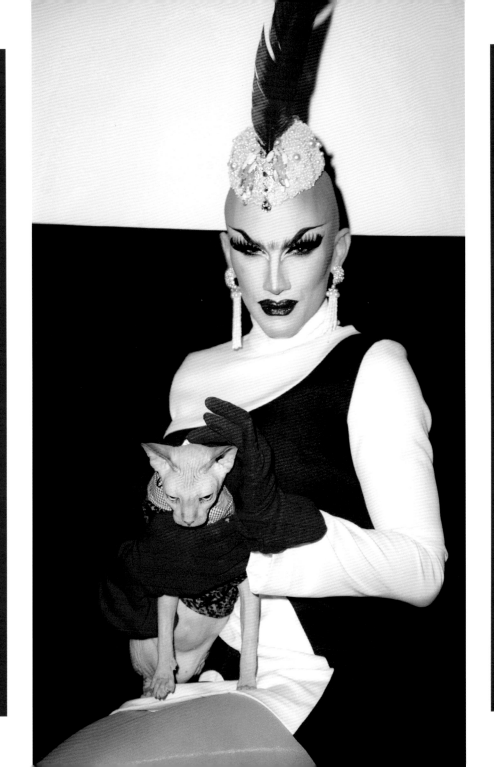

Shangela

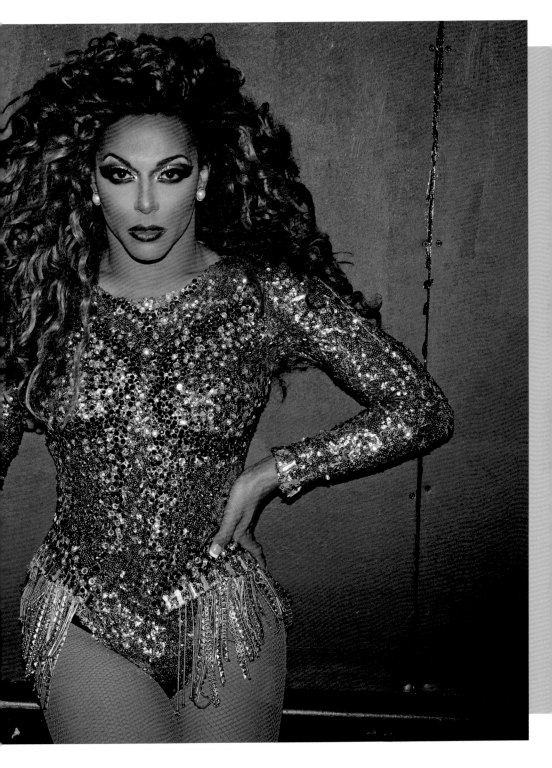

Sharon Needles

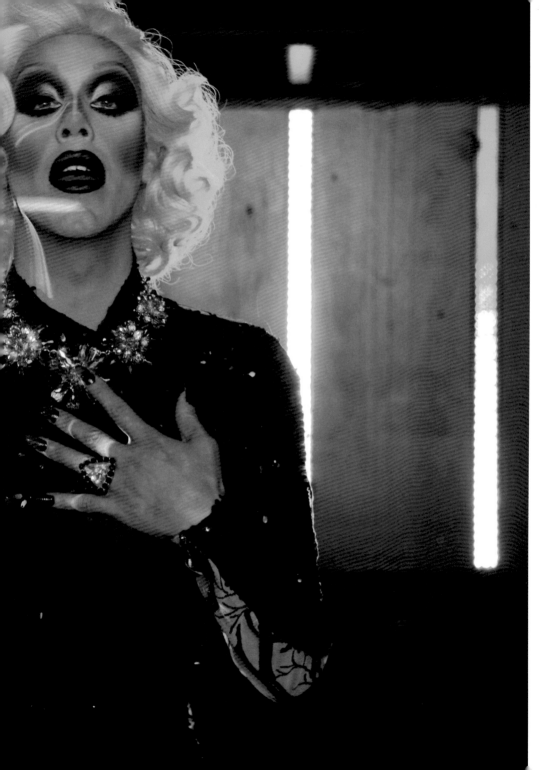

"Drag to me is not the
act of emulating a woman,
but an exaggeration of
the hyper-sexualized,
western commercial expectations
that men put on women.
Also, a drag queen can be defined as a

CROSS-DRESSING, COKE-SNORTING, COCK-SUCKING, ALCOHOLIC, SHOPLIFTING ASSHOLE."

Sharon Needles

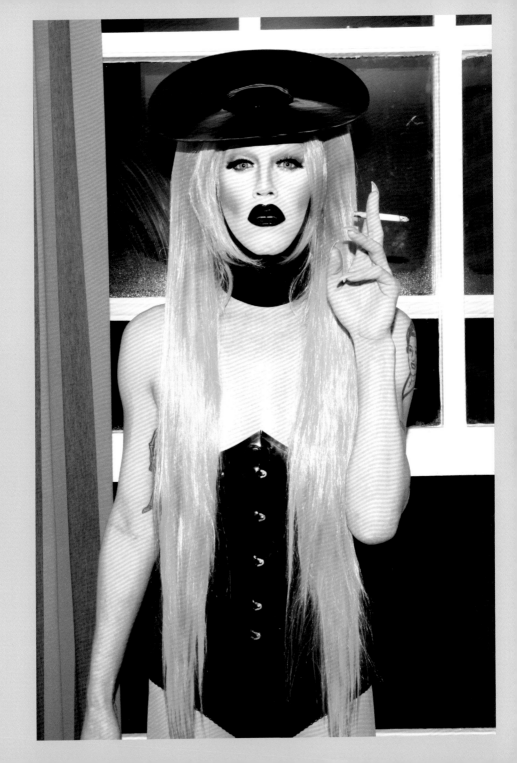

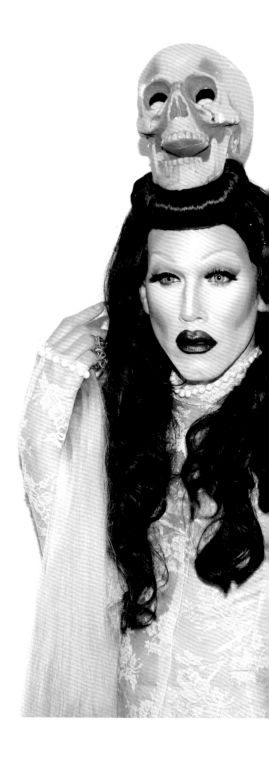

Sharon Needles

Sharon Needles

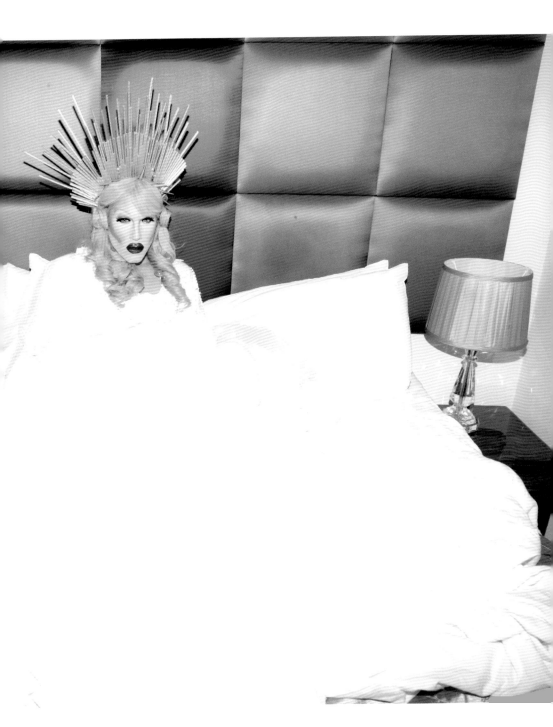

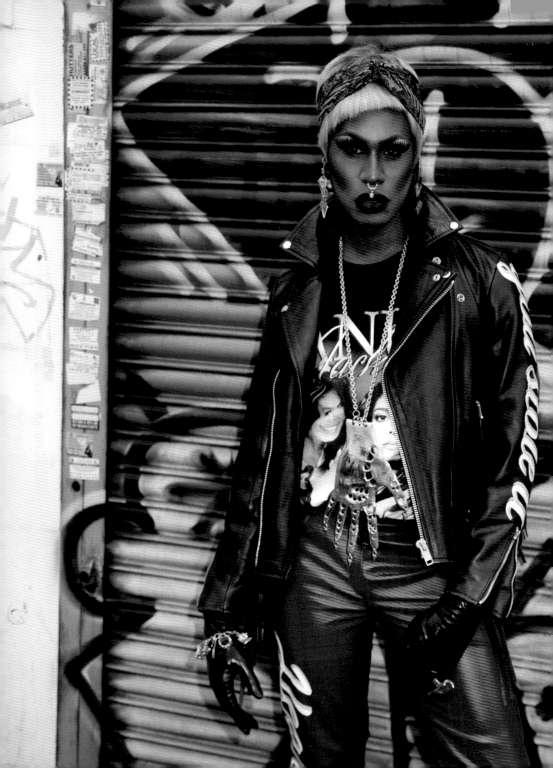

Shea Couleé

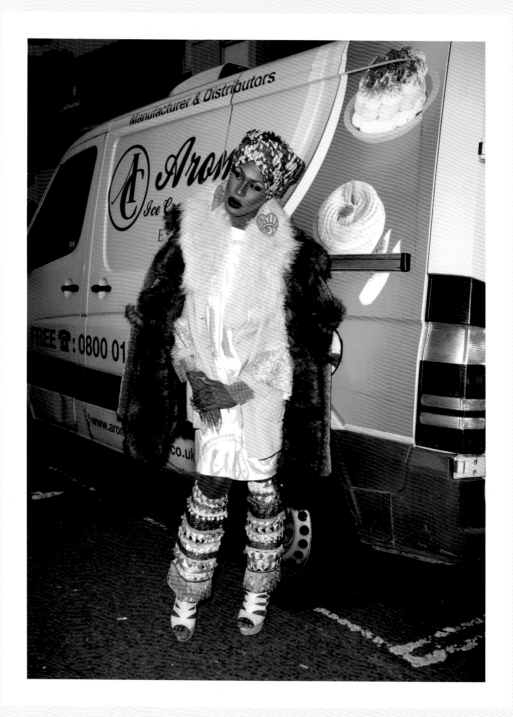

Shea Couleé

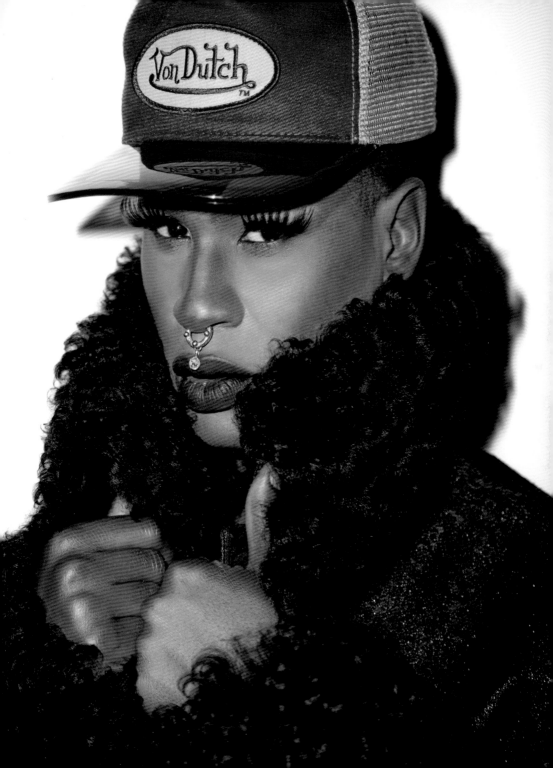

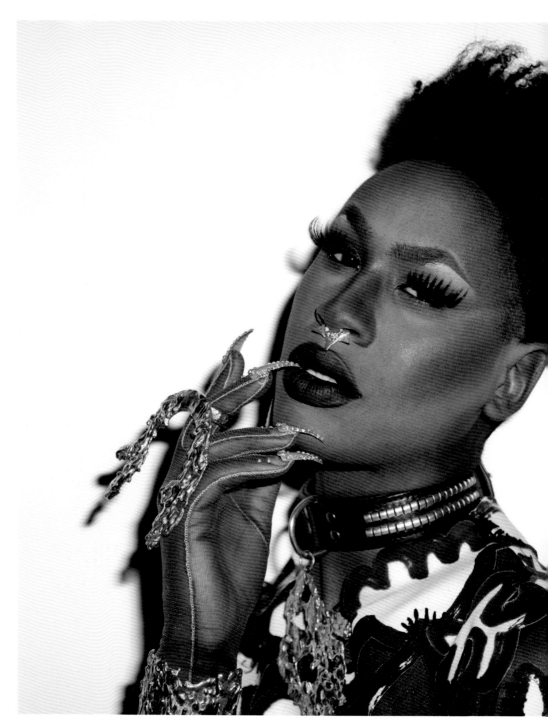

Shea Couleé

"They are always gonna love you or hate you. So I rather they hate me for being AUTHENTIC, than love me for being fake."

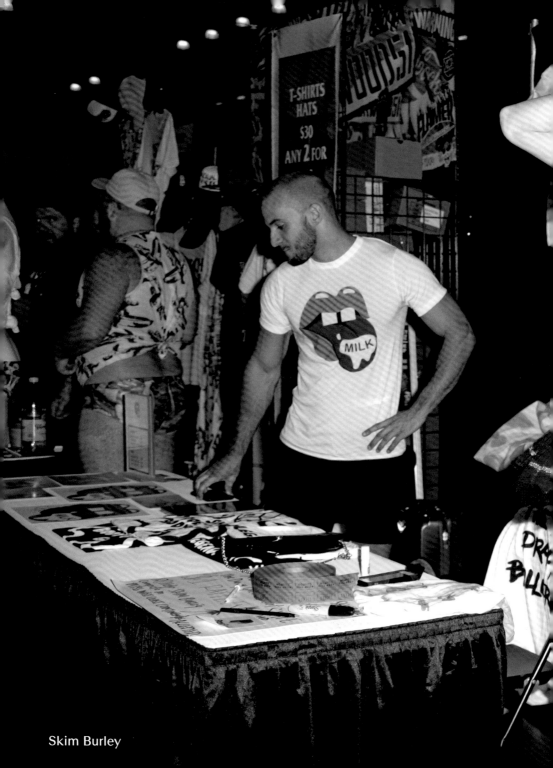

Skim Burley

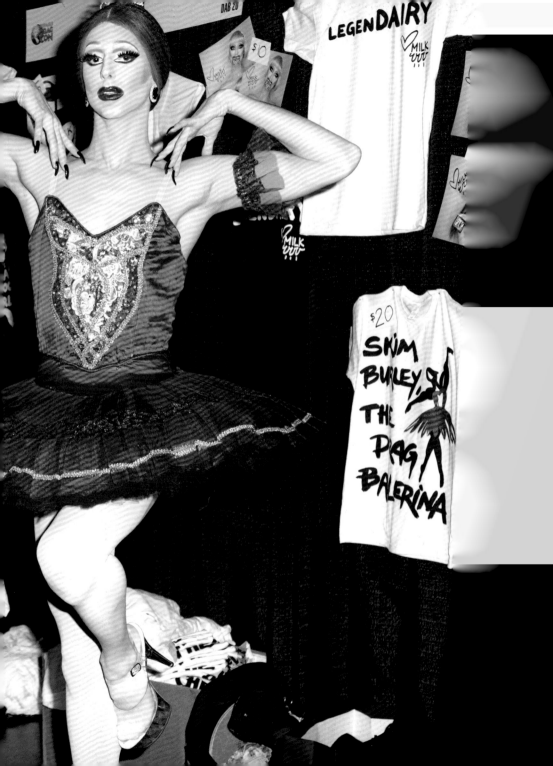

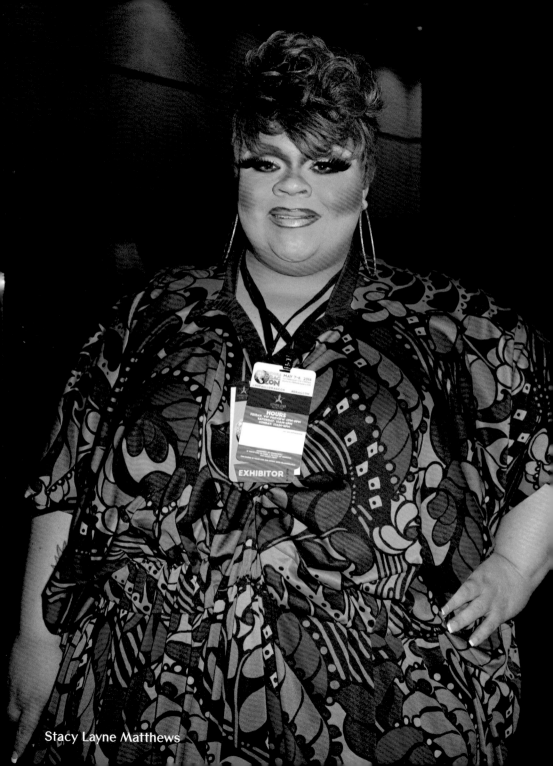

Stacy Layne Matthews

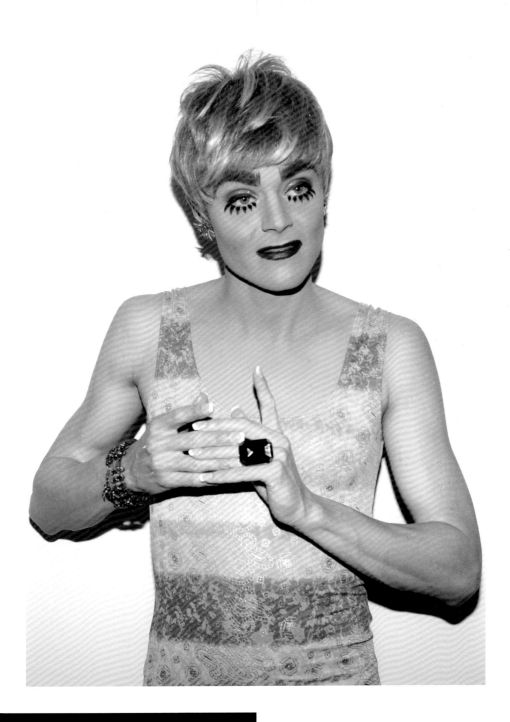

Tammie Brown

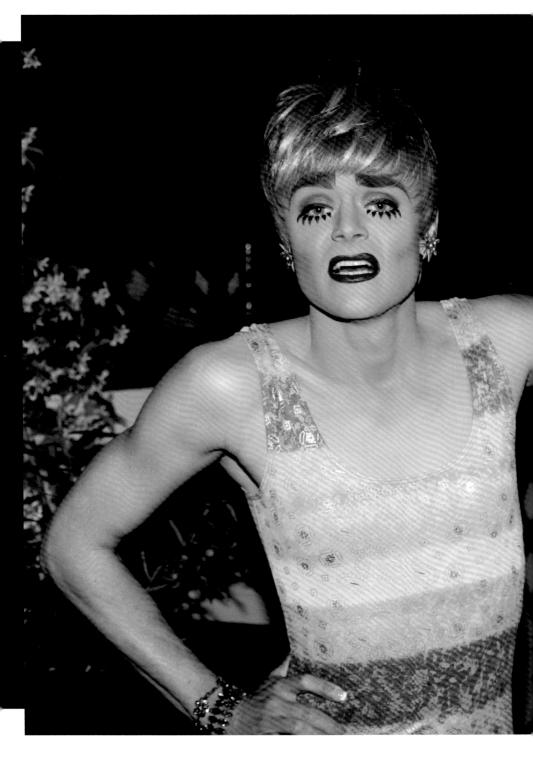

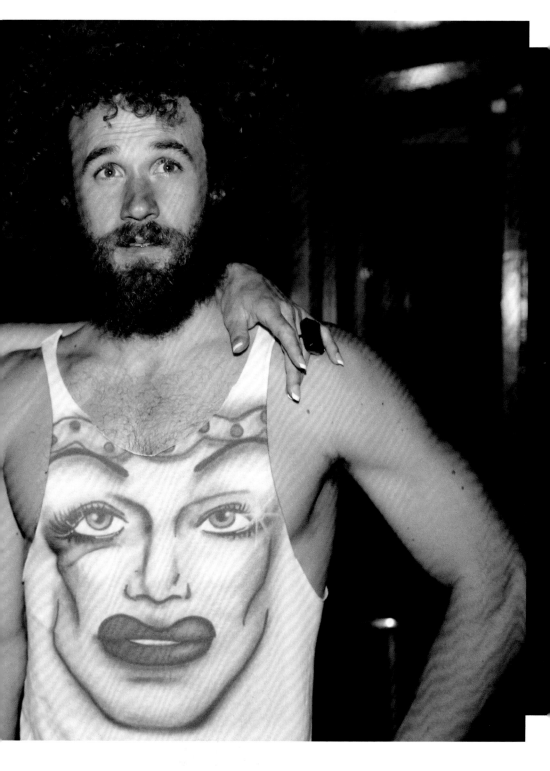

Tatianna

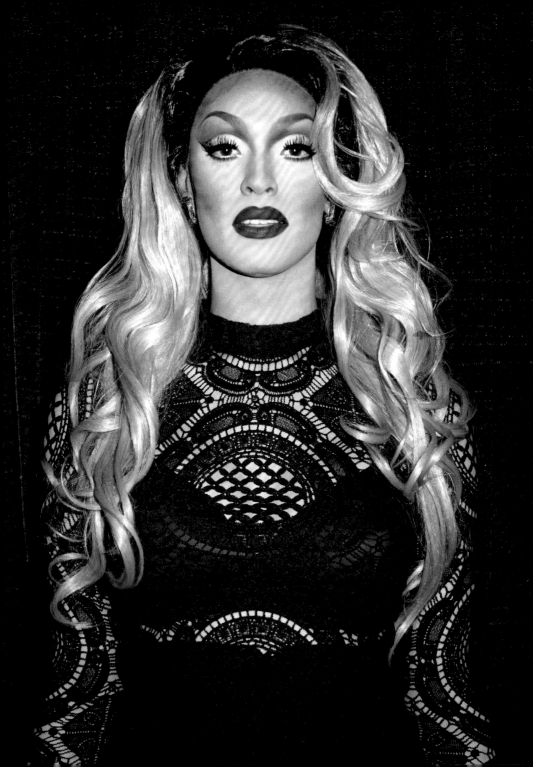

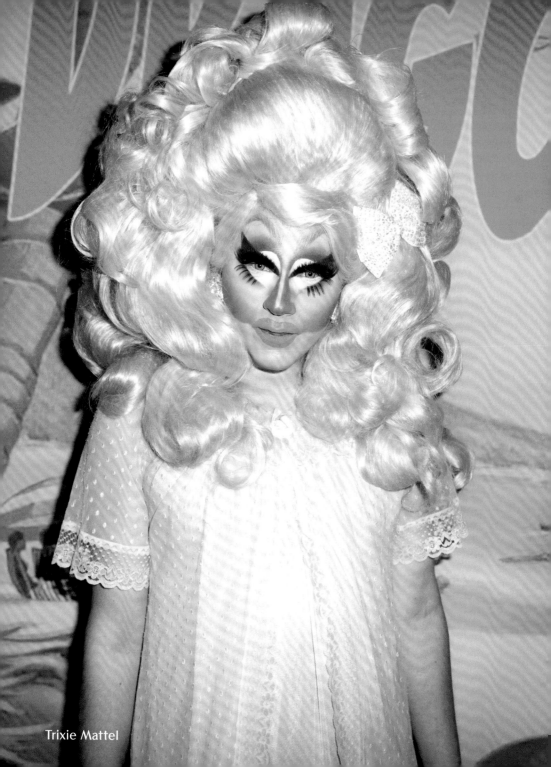

Trixie Mattel

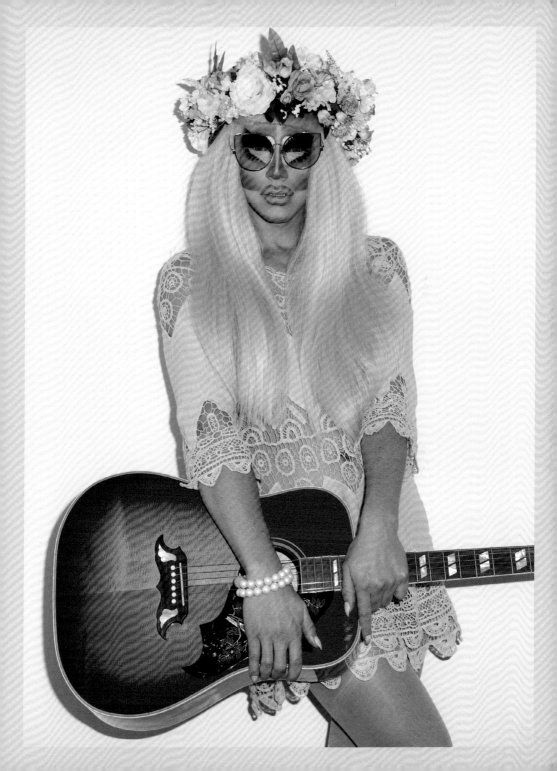

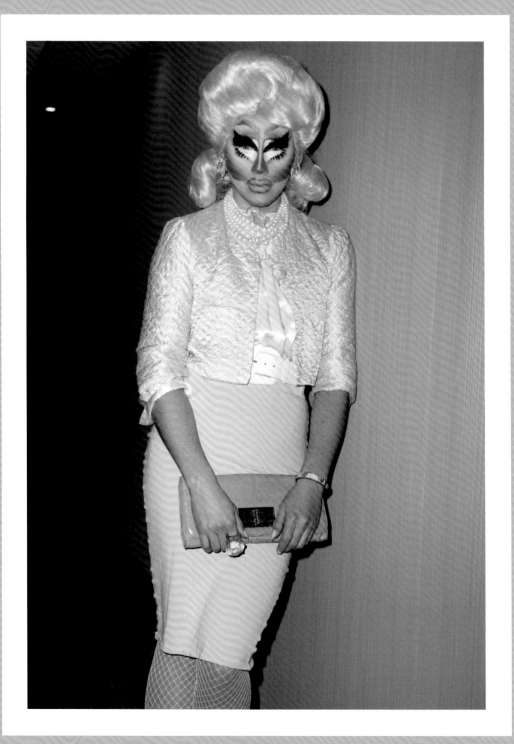

"PEOPLE SAY THEY **LOVE DRAG,** BUT ONLY WATCH IT ON TV. THAT'S LIKE SAYING YOU LOVE MUSIC BUT ONLY WATCH *AMERICAN IDOL.*"

Trixie Mattel

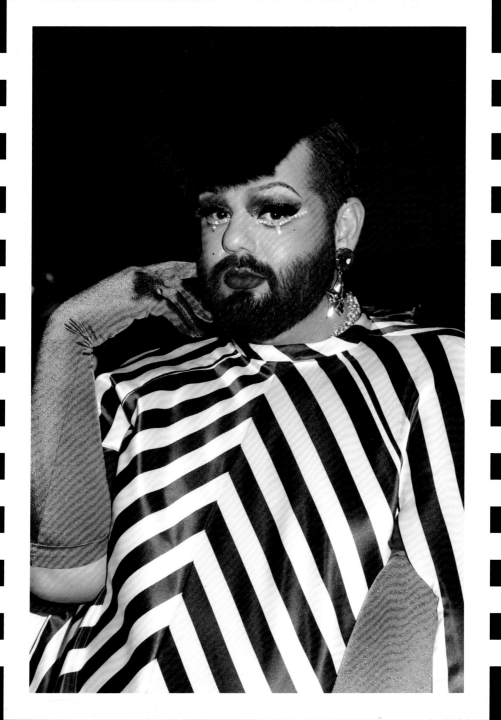

Vicky Vox

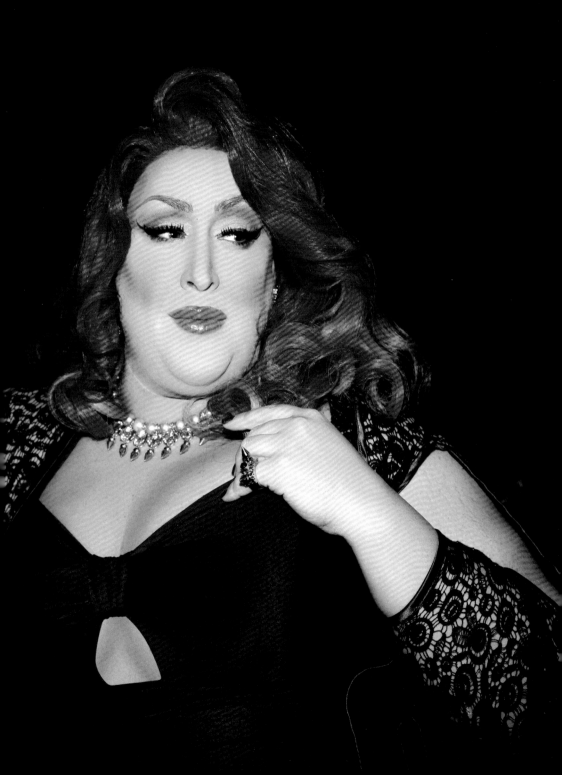

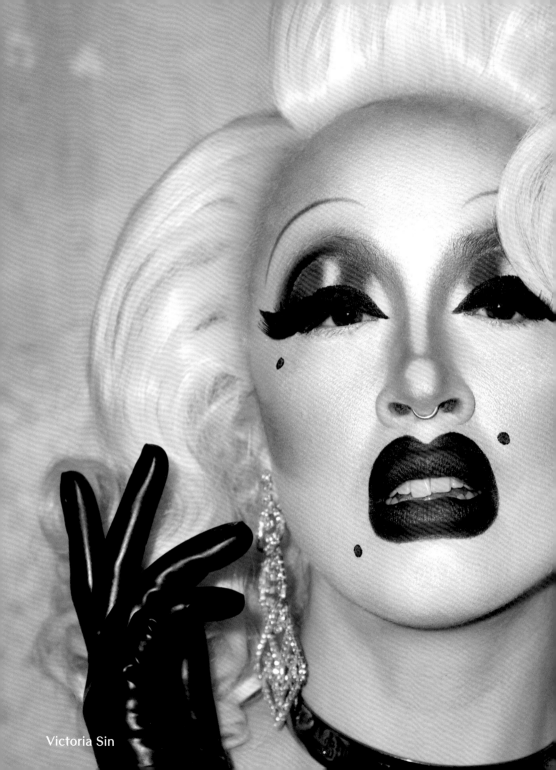

Victoria Sin

"I think young people getting into drag is a great thing. Maybe it will instil

from an early age

that GENDER IS SOMETHING THAT CAN BE PLAYED WITH

rather than something to measure people against."

Victoria Sin

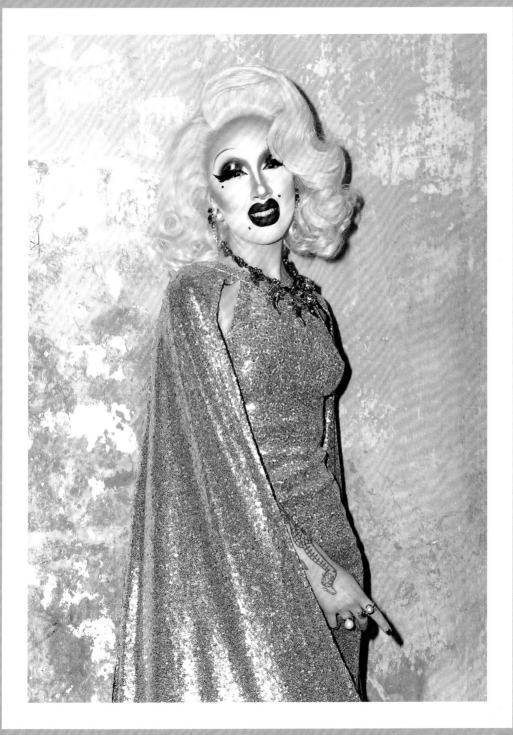

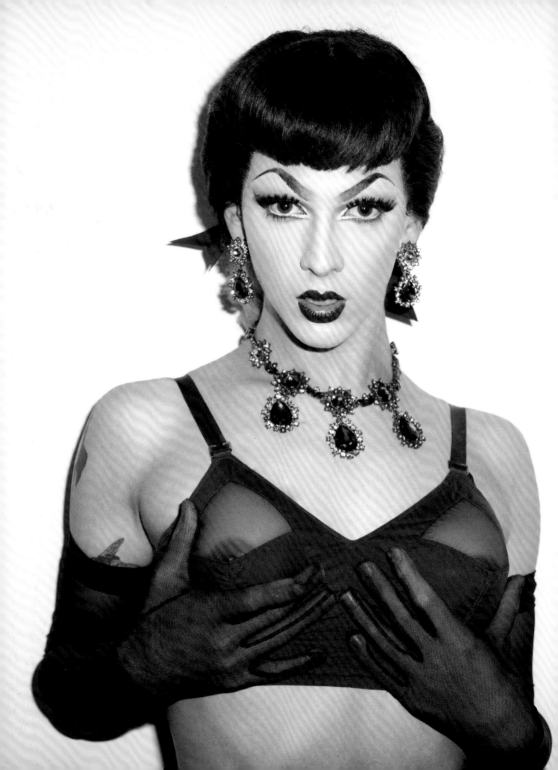

Violet Chachki

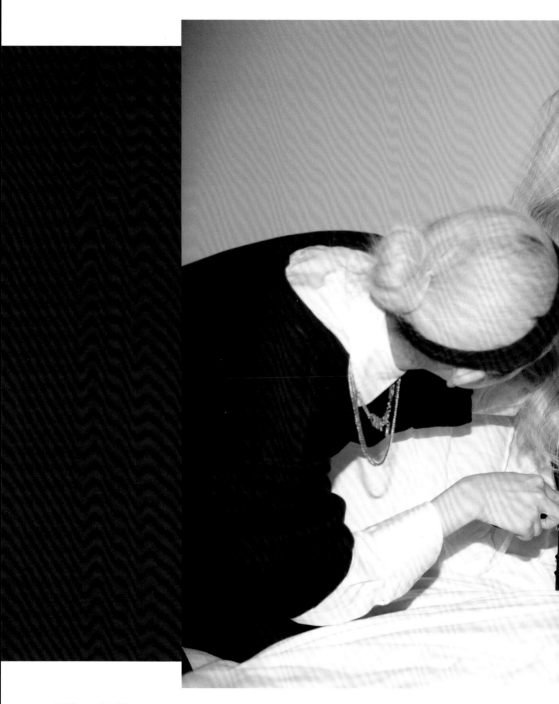

Willam Belli

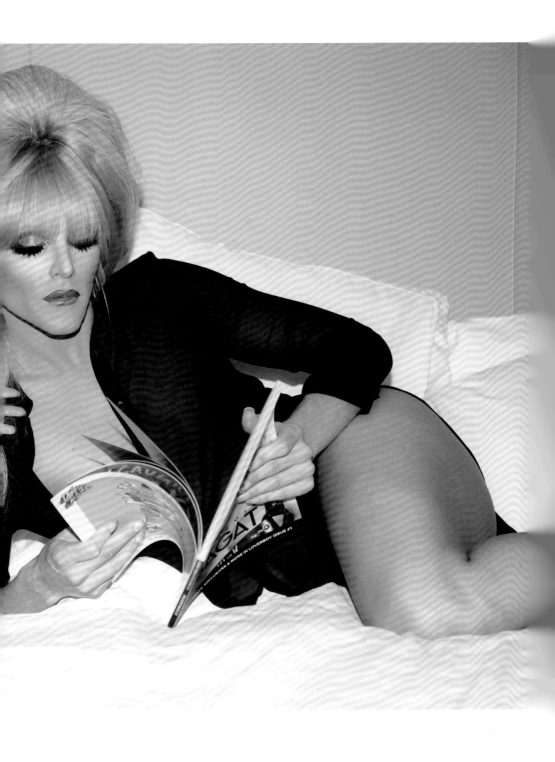

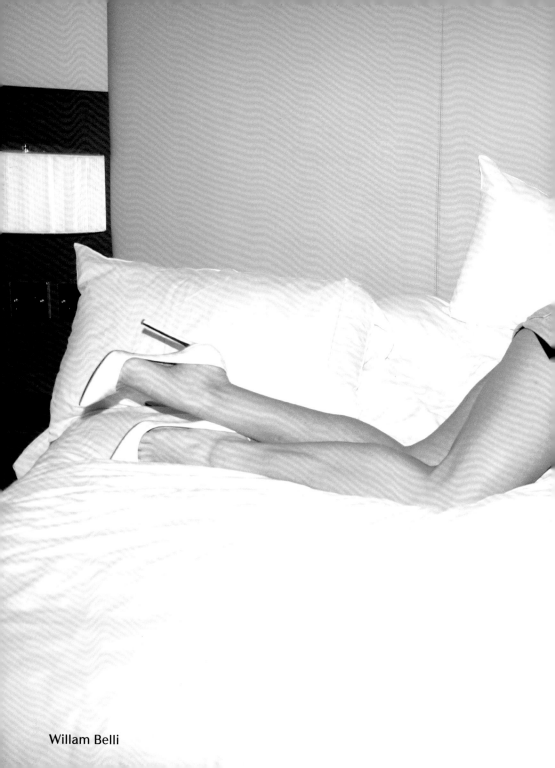

Willam Belli

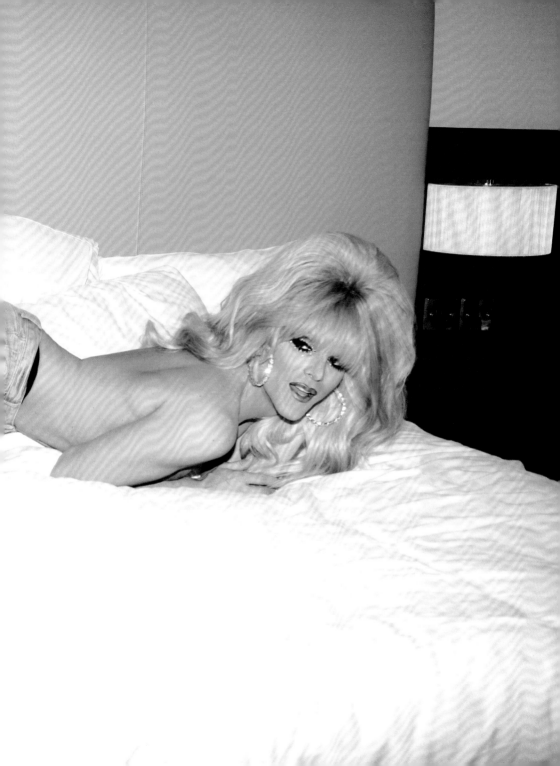

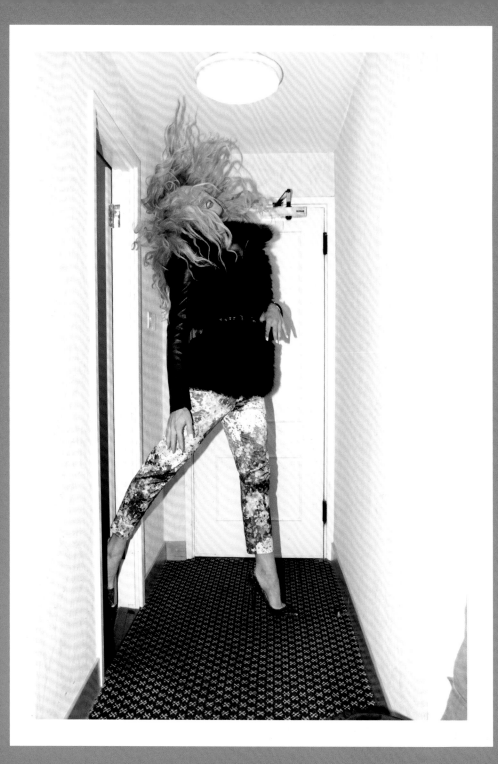

"I'LL NEVER TAKE CLAIM TO BEING A CELEBRITY. I'M A NOVELTY AT BEST."

Willam Belli

Willam Belli

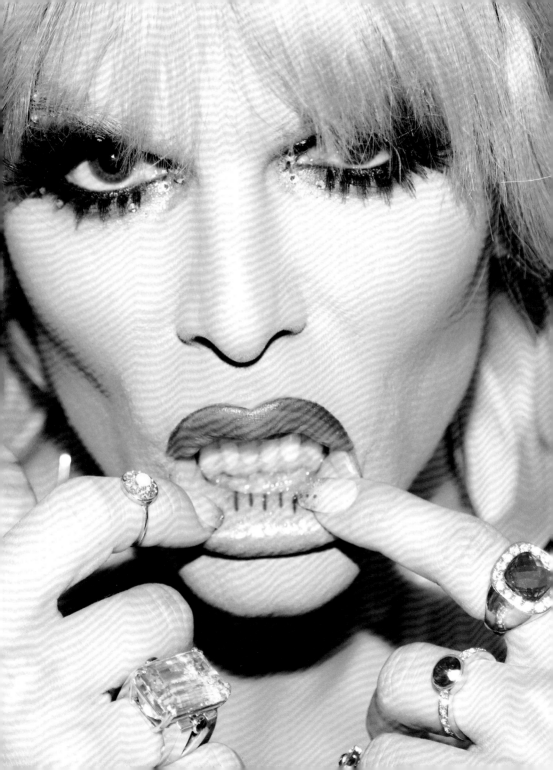

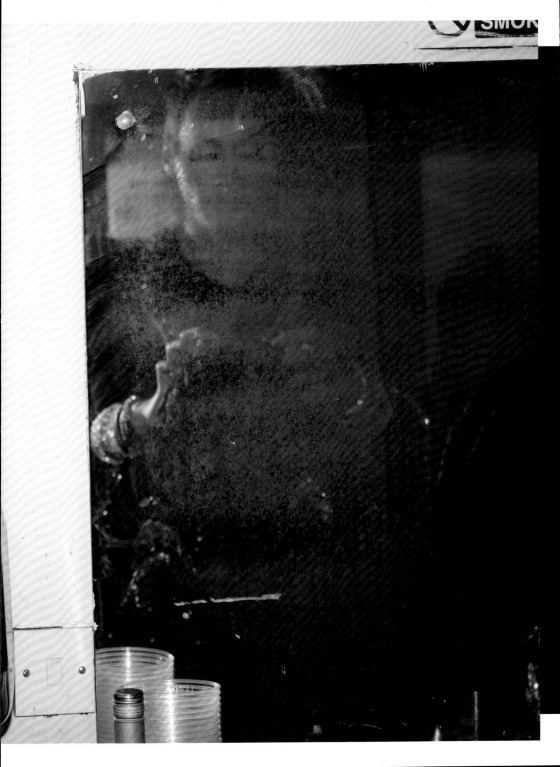

Published in 2018 by
Laurence King Publishing Ltd
361–373 City Road
London EC1V 1LR

e-mail: enquiries@laurenceking.com
www.laurenceking.com

A catalogue record for this book
is available from the British Library.

ISBN: 978 1 78627 287 4

Design: Pony Ltd, London
Senior editor: Andrew Roff

Printed in China

UNCAPTIONED IMAGES:
i: Arran Shurvinton, Joe Black
ii: Maxi More, Lilly SnatchDragon
iii: The many wigs of Cherry Liquor
iv: AAA Girls (Courtney Act,
Alaska Thunderfuck, Willam Belli)
v *AFTER CHEDDAR GORGEOUS*: Maxi More,
Cheddar Gorgeous, Ruby Wednesday
vi *AFTER JODIE HARSH*: Jodie Harsh, Detox
vii *AFTER LYDIA L'SCABIES*: Joe Black,
Lydia L'Scabies, Coco Deville
viii *AFTER RAJA GEMINI*: Raja Gemini, Milk
ix *AFTER RAVEN*: Jujubee, Raven
x *AFTER TAMMIE BROWN*: Tammie Brown,
Michael Catti
xi *AFTER WILLAM BELLI*: Freight box at RuPaul's
DragCon 2016
xii: backstage at The Black Cap, London
xiii: Katya's coat and shoes with
Alright Darling issue 2
xiv: Violet Chachki, Adore Delano
xv: Victoria Sin's facewipe

Alaska Thunderfuck foreword image and in
white; Detox against blue wall; Jinkx Monsoon
with red hair; François Sagat; and Lady Munter:
makeup by Joseph Harwood.

AUTHOR'S ACKNOWLEDGEMENTS
This book would not have been possible
without the collaborations with countless
stylists, writers, makeup artists, designers,
hairstylists and wig makers; the free
backstage entry from club promoters and
hosts; and all the performers and queens who
have allowed me to tail them with my camera.

I want to acknowledge the understanding,
patience and help of my partner. Even when
I am sure it seemed like it was a fruitless
pursuit of mine, you still put up with my
free time being spent away on photoshoots,
my late nights on the computer responding
to emails, and my hours spent compiling
the next issue of the zine. Thank you
for being there with me for all of it.

To everyone who has believed in me
over the years and who has helped
me in one way or another, thank you.

Greg Bailey is a UK-based photographer,
and the editor of the zine *Alright Darling*,
a periodical that celebrates the LGBTQ+
community and spotlights talent within
the contemporary drag scene.

LAURENCE KING

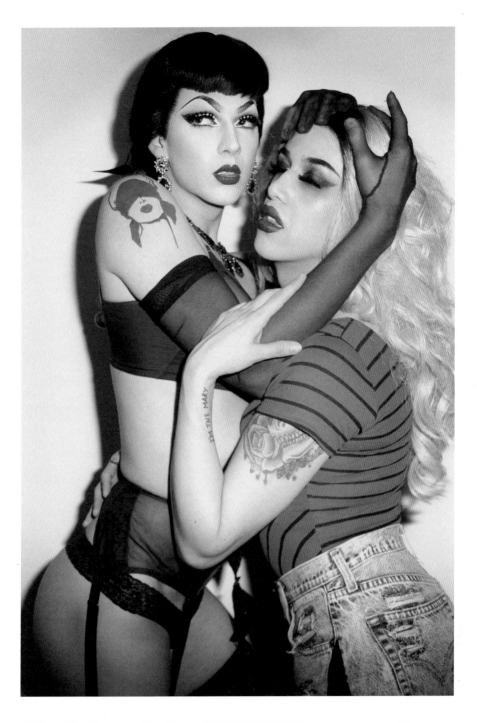